THE pip EXPANDED GUIDE TO THE
NIKON D70

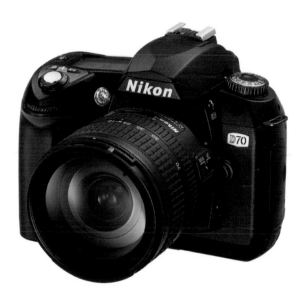

Chris Weston

photographers'
pip
institute press

THE pip EXPANDED GUIDE TO THE

NIKON D70

Chris Weston

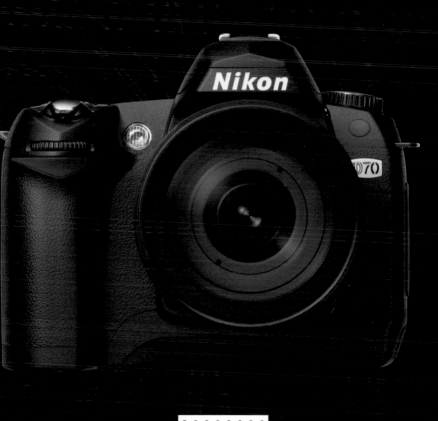

photographers'
pip
institute press

First published 2004 by
Photographers' Institute Press / PIP
an imprint of The Guild of Master Craftsman Publications Ltd,
166 High Street, Lewes, East Sussex BN7 1XU

Reprinted 2006 (twice)

ISBN-13: 978-1-86108-334-0
ISBN-10: 1-86108-334-3

British Cataloguing in Publication Data. A catalogue record of this book is available from the British Library.

Production Manager: Jim Bulley
Managing Editor: Gerrie Purcell
Studio Photography: Anthony Bailey
Editor: James Beattie
Managing Art Editor: Gilda Pacitti

Typefaces: Frutiger and Sabon
Colour reproduction by Masterpiece, London
Printed in China by Hing Yip Printing Company Ltd

THE NIKON D70

The speed of technological progress is astounding; and you need look no further than the field of photography for evidence of this. Since the late 1980s a great deal of pioneering work has been undertaken in the field of digital imaging. While early digital cameras borrowed heavily from their film counterparts, the 1990s saw them develop in their own right, and by the beginning of the 21st century digital cameras had already persuaded many professional photographers of their usefulness.

For an ever-increasing range of applications, both professional and consumer alike, digital photography is not just the future but the present. The massive growth in the popularity of digital SLRs represents the fact that photography enthusiasts are making the move to digital capture in droves. The combination of improving quality and falling prices has made the digital process irresistible to many. At the forefront of this revolution is the award-winning Nikon D70, a remarkable camera that combines the latest technology with easy-to-use functions. The D70 possesses the simplicity required by many inexperienced digital photographers, while still managing to offer the almost endless versatility of a Nikon SLR.

At one time digital photography was viewed as an unwelcome intrusion on the dominance of film. Now, as the digital revolution gathers pace, more and more people are switching on to the benefits of digital. The D70 is a remarkable camera that allows you to take advantage of these benefits and at the same time expand your photographic horizons beyond what you might think possible. Welcome to the Nikon D70.

Contents

How the **D70 evolved**

The basic principles that determine how a camera operates have remained unchanged since the camera's invention – and this is as true for digital photography as it is for film.

In the 11th century the camera obscura (meaning 'dark chamber'), consisting of a room with a small hole in an outside wall, was used to observe solar eclipses. Rays of light passed through the hole, forming an image on the interior wall.

Permanent Image
In 1824 a French lithographer, Nicéphore Niépce, discovered that, by coating a pewter plate with asphaltum, a permanent image

1995 – Nikon E2s
Nikon's first digital SLR, the E2s, was produced in cooperation with Fuji, and based, in part, on the Nikon F-801s. The lower-spec E2 model was produced at the same time and although both cameras possessed a sub-35mm 1.3-megapixel sensor they maintained lens focal lengths via a series of reduction optics.

1996 – Nikon E2Ns
The E2Ns and its pared-down sibling the E2N were also developed with Fuji and featured the same core technology and reduction optics as their predecessors. However, they did improve the performance of the range by increasing the maximum frame capture rate to three frames per second.

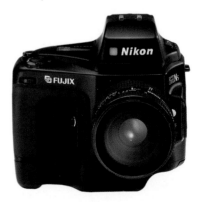

could be recorded. In 1841, six years after producing the first negative, William Henry Fox Talbot patented the Calotype – a negative-positive process using paper treated with nitrate of silver.

The Perfect Camera

The evolution of photographic apparatus, especially the camera, is ongoing. Of course, there is no such thing as the 'perfect' camera. Everything in photography is subject to compromise – what is good in one respect can lead to deficiencies in another. More often

than not, camera design is a question of quality versus practicality and cost.

Large-format field cameras, which require sheet film, bellows and viewing screens, and must be mounted on a tripod, are cumbersome and slow to operate. Yet, when used properly, they offer total control over the picture-making process, and deliver high-quality images that are still in demand in many commercial fields. The pursuit of a camera that combined acceptable image quality with expediency led to the development

1998 – Nikon E3s

Based on the same 1.3-megapixel sensor as their predecessors, the E3s and E3 digital SLRs offered improved exposure control via a greater range of ISO-equivalent ratings, shutter speeds and aperture settings. The E3 range also enabled users to connect to a computer in order to control camera functions.

1999 – Nikon D1

The launch of the D1 broke new ground for Nikon. Not only did the new camera boast a much larger – 2.7-megapixel – CCD but it also ditched the bulky reduction optics of the earlier E-series, this significant redesign meant that effective focal lengths were now multiplied by a factor of 1.5.

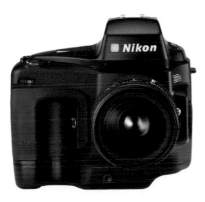 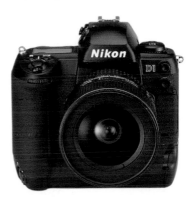

of small-format cameras. With the conviction that, once freed from the constraints of the tripod, the studio and the chemist's bench, the camera would open up new photographic frontiers, George Eastman developed the Kodak Box Brownie. For the first time a knowledge of optics and chemistry was no longer an essential requirement for photographers.

Further developments in the early 20th century, such as the first Leica that combined the advantages of the small portable camera with the potential for using

cinematographic 35mm film, blazed the trail for the cameras we know today. The subsequent development of high-quality optics, together with improvements in film and now digital technology, has allowed small-format cameras to produce ever-improving images.

Camera designers have continued this process, taking the onus of knowledge from the user, and automating the camera more and more. While, early 35mm cameras required at least an understanding of exposure; modern electronic cameras allow users to

2001 – Nikon D1X and D1H

Nikon shook the digital world with the twin launch of two new cameras, each based on the D1 but aimed at different parts of the professional market. The D1X offered higher resolution with a 5.3-megapixel sensor, while the D1H boosted capture speeds to five frames per second for up to 40 consecutive shots.

2002 – Nikon D100

Based on the popular F80/N80 film SLR, the D100 and its relatively low price opened up digital SLR photography to a wider market. Despite the price tag, the D100 was the first Nikon camera to incorporate a 6.1-megapixel sensor that offered users comparable quality to professional-standard transparency film.

create perfectly acceptable images without knowing the basics of photography.

Taking Control

In order to achieve individualism in photography it is necessary for the photographer to wrest back control from the camera. The ability to make the camera perform to our own wishes are what sets the photographer apart from the 'snapper', and it is this that has led to the rise of the digital camera. For the first time, photographers can take a picture, review and analyse the result, make any necessary adjustments and re-shoot the scene for almost instant success. Never before have photographers had as much control over the in-camera picture-making process as they do today.

Even with the advantages of digital technology it takes a lot of skill to get it right time after time; and *The PIP Expanded Guide to the Nikon D70* will provide you with the knowledge and skill to operate the D70 to its and your own full potential, in almost any photographic situation.

2003 – Nikon D2H

The D2H answered many of the criticisms that had been aimed at the D1H. Frame advance was improved to eight frames per second for the maximum burst of 40 frames. Image quality was enhanced by a 4.1-megapixel sensor and a new 11-area autofocus system. Wireless transmission also made the camera extremely flexible.

2004 – Nikon D70

Although the D70 resembles the D100, it is far more than a scaled-down model. The brand new CCD and high-specification features give the D70 a life of its own. As the first Nikon digital SLR with a release price of less than US$1,000 the D70 brings digital SLR photography to the masses like never before.

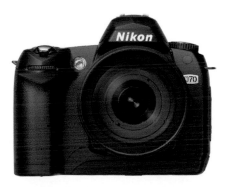

Introduction to the **D70**

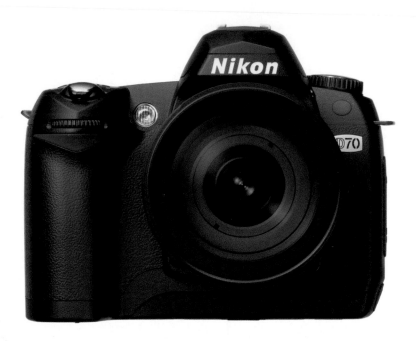

Launched in 2004, the D70 is Nikon's first sub-US$1,000 digital SLR camera. As the least costly camera in the Nikon digital SLR range the D70 competes with cameras such as Canon's EOS 300D/Digital Rebel, Pentax's *ist D and Sigma's SD10 in the consumer digital camera market.

The D70 shares many of the features of its more robust (and more expensive) cousin, the D100, which was launched exactly two years earlier. However, to consider the D70 as merely a stripped down version of the D100 would be an unfair comparison. Indeed, many people's first reaction to the D70 was just the opposite.

The D70 differs from the D100 in its simpler and lighter body, larger menu typeface and lack of an optional vertical handgrip. So, the differences appear to be largely cosmetic. However, a closer

inspection reveals a camera that, in many ways, can hold its own with more expensive competitors.

Simplicity

The D100 is aimed at the semi-professional market and has a metal-alloy body built to withstand the demands of professional photography, the D70, however, has been designed with the enthusiast in mind. Nikon has built a camera that will produce outstanding-quality images without over-complicating the picture-taking process. The combination of a new DX-format 6.1 effective megapixel CCD with Nikon's 1,005-pixel RGB sensor simplifies image processing. While the D70 also features a simple dial to control the exposure mode, and a 1.8 inch 130,000 pixel LCD monitor, for clear playback images and easy access to menu functions.

Versatility

Three metering modes are available: spot, centre-weighted and, using the 1,005 pixel RGB sensor, 3D colour matrix (with type D and G lenses) or non-3D colour matrix (with other CPU lenses).

The autofocus (AF) system is inherited from the D100 and is managed by Nikon's five-area Multi-CAM900 system with single and continuous servo AF modes and single area, dynamic area and dynamic area with closest subject priorities. A white lamp provides AF assistance in low-light, and the camera can also be switched to manual focusing mode.

The shutter is a combination mechanical and electronic type with no noticeable time lag. Images are recorded to either type I or type II CompactFlash cards, or to a Microdrive. Files are saved in either RAW NEF (Nikon Electronic Format) or JPEG format – there is no TIFF option – and images can be saved simultaneously as both NEF and JPEG files.

Some other enhancements to the D70 round off what is an exceptional camera for its price. The top shutter speed is 1/8,000sec and flash synchronization can be performed up to 1/500sec. File transfer is also improved to meet the USB 2.0 standard.

Note

The serial number of your camera is required if you are to download Nikon firmware or correspond with Nikon about your D70. This can be located on the underside of your D70 above the information panel containing the camera's make and other details.

Main Features

Sensor Nikon DX-format 6.31 megapixels (6.1 effective megapixels) RGB CCD measuring 23.7 x 15.6mm, producing a maximum image resolution of 3,008 x 2,000 pixels.

Focus Cross-ranged, five-area multi-CAM900 AF sensor with wide horizontal and vertical coverage. Three AF modes: single area, dynamic (automatically shifts from one sensor to another when tracking moving subjects) and dynamic with closest-subject priority. There is an AF-assist illuminator for subdued light. The D70 can also be switched to manual focus.

Exposure 3D colour matrix metering (with D- and G-type lenses) with a 1,005 pixel RGB sensor and a database of over 30,000 scenes for exposure evaluation. There are also variable centre-weighted and selective spot metering options with four exposure modes: auto multi program (**P**), aperture-priority (**A**), shutter-priority (**S**) and manual (**M**). The D70 features seven digital vari-programs: auto, portrait, landscape, close-up, sports, night landscape and night portrait. Bracketing and exposure compensation are also available.

Burst rate Three frames per second in continuous shooting mode. The D70 simultaneously processes images in the memory buffer and, if used with certain memory cards, a continuous burst of 144 images is possible.

Built-in Speedlight The built-in flash has a guide number of 49/15 (ISO 200 ft/m). Balanced i-TTL fill-in flash metering or standard i-TTL flash (for spot metering and manual exposure mode) and auto-flash in auto, portrait, close-up and night portrait modes. Flash can be activated manually and front-curtain, red-eye reduction, slow, slow with red-eye reduction, rear-curtain and slow rear-curtain synchronization modes are available.

Custom settings A total of 25 custom setting functions are available to change the way your D70 operates.

System back-up The D70 will accept all DX-type, G- and D-type Nikkor lenses with full functionality. In addition most other Nikon F-mount lenses are supported with limited functionality. External Speedlights SB-800 and SB-600 provide i-TTL flash control, and remote shooting is possible via the ML-L3 infrared control device. Nikon View or PictureProject image management software is included and the optional Nikon Capture software is also available.

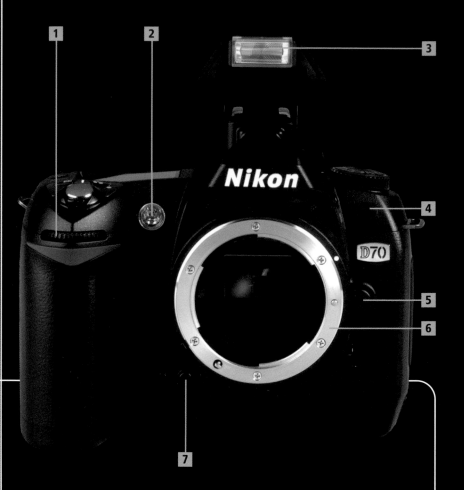

FRONT OF CAMERA

1 Sub-command dial

2 Self-timer indicator / AF-assist illuminator / Red-eye reduction lamp

3 Speedlight

4 Infrared receiver

5 Lens release button

6 Lens mount

7 Depth-of-field preview button

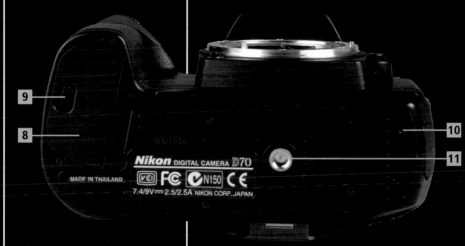

CAMERA BASE

8 Battery-chamber cover
9 Battery-chamber cover release latch
10 Reset switch
11 Tripod screw socket

LEFT SIDE

12 Speedlight lock-release button / Flash sync mode button / Flash exposure compensation button
13 Camera strap eyelet
14 DC-in connector / Video connector
15 Focus mode selector
16 USB connector

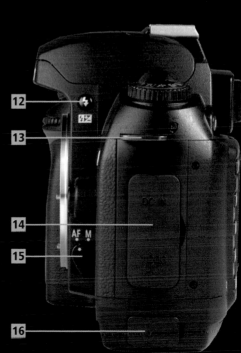

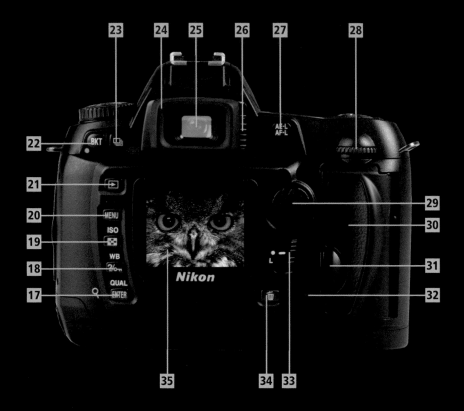

BACK OF CAMERA

17 Image quality and size button / Playback zoom access button / Enter button

18 White balance button / Image protection button / Help button

19 ISO equivalency button / Thumbnail selector button / playback zoom button

20 Menu button

21 Image playback button

22 Auto-bracketing button / Reset

23 Shooting mode button / Format button

24 Viewfinder eyepiece cup

25 Viewfinder eyepiece

26 Dioptre adjustment control

27 AE/AF lock button

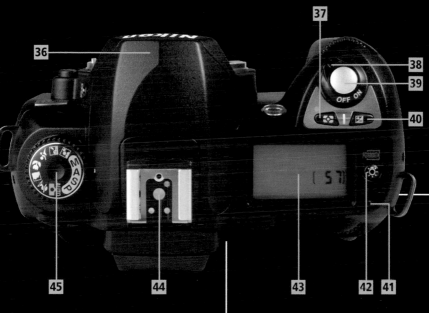

TOP OF CAMERA

36 Built-in Speedlight above Penta-mirror housing

37 Metering mode button / Reset

38 Power switch

39 Shutter-release button

40 Exposure compensation button

41 Focal plane indicator mark

42 LCD illumination / Format button

43 LCD control panel

44 Accessory shoe

45 Mode dial

28 Main command dial

29 Multi selector control

30 Memory card holder cover

31 Memory card holder cover latch

32 Memory card access lamp

33 Focus selector lock switch

34 Image delete button

35 Playback / menu monitor

Using the mode dial

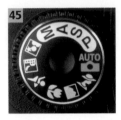

Mode dial 45

Rotating the mode dial allows you to select one of four traditional exposure modes: manual (**M**), aperture-priority (**A**), shutter-priority (**S**) or auto multi program (**P**); or one of seven digital vari-program modes that automatically select exposure, flash, focus and other variable settings to suit the subject being photographed.

Exposure modes

Exposure modes allow the user control over exposure variables that enable photographers to creatively manipulate the way an image is recorded. A brief outline of the available exposure modes is given below. For more details and advice on using them see pages 84–91.

(P) Auto multi program
In **P** mode the camera sets both the aperture and the shutter speed depending on the subject being photographed. Some flexibility is available and rotating the main command dial selects 'flexible program' mode and changes the combination of shutter speed and aperture, although the overall exposure value remains the same.

(S) Shutter-priority auto
With the D70 set to the **S** mode, the photographer can rotate the main command dial to select the required shutter speed and the camera will choose an appropriate aperture. Normally, shutter-priority auto mode is used when you want to freeze fast-moving action, such as in sports and some wildlife photography, or when you want image blur to give the appearance of motion.

(A) Aperture-priority auto
In **A** mode, the photographer rotates the sub-command dial to set the lens aperture, while the D70 automatically selects the shutter speed. This mode is useful when you want to control depth of field; a wide aperture (low f-number) gives a shallow depth of field useful for portraiture, while a narrow aperture (high f-number) gives a great depth of field often used for landscape or architectural photography.

(M) Manual mode
In **M** mode the photographer has full control over both the lens aperture (sub-command dial) and the shutter speed (main command dial). The viewfinder's electronic analogue exposure display provides exposure information. Use this mode when you want to retain complete control over exposure.

Digital vari-program modes

Digital vari-programs make taking pictures easy. The seven modes set exposure, focus, flash and other variables, removing the need for the photographer to make technical decisions. They record images in the sRGB colour space – the most appropriate for printing images without digital manipulation.

Auto

The D70 selects shutter speed and aperture, the focus area over the object closest to the camera is selected and single-servo autofocus prevents shots from being taken out of focus. Flash is set to front-curtain sync, although other modes are also selectable. See page 85.

Portrait

The D70 selects a wide aperture to render the subject in-focus with the background in soft focus. Autofocus is on the closest subject and only in-focus shots can be taken. Flash is set to front-curtain sync, although auto with red-eye reduction and off modes are also available. See page 85.

Landscape

The D70 selects a narrow aperture that maximizes depth of field. The focus area over the object closest to the camera is selected and single-servo autofocus prevents out-of-focus shots being taken. The built-in Speedlight and the AF-assist illuminator are turned off. See page 85.

Close-up

The D70 selects a shutter speed/aperture combination to make the subject stand out from its background and the focus area can be changed. Flash, if required, is set to front-curtain sync, although auto with red-eye reduction and off modes are also selectable. See page 86.

Sports

The D70 selects a fast shutter speed in order to freeze motion. The camera focuses on the closest subject, and the in-focus beep is disabled. Continuous-servo autofocus mode is selected. Both the built-in Speedlight and the AF-assist illuminator are turned off. See page 86.

Night landscape

The D70 selects a slow shutter speed and the appropriate aperture. The focus area covering the object closest to the camera is selected and in default mode single-servo autofocus prevents shots from being taken out of focus. Both the built-in Speedlight and the AF-assist illuminator are turned off. See page 86.

Night portrait

The D70 selects a slow shutter speed (down to one second) to produce portraits against a dimly lit background. The focus area covering the object closest to the camera is selected and the built-in Speedlight is set to auto slow sync, although auto slow sync with red-eye reduction is also selectable. See page 87.

Viewfinder display

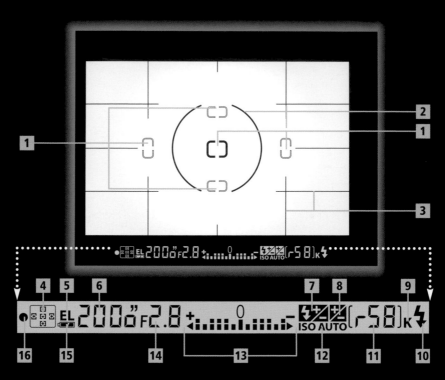

1 Focus brackets / Spot metering reference brackets

2 8mm reference circle (for centre-weighted metering mode)

3 Custom selectable reference grid

4 Focus area / AF-area mode

5 Autoexposure lock / Flash output lock indicator

6 Shutter speed

7 Flash exposure compensation indicator

8 Exposure compensation indicator

9 'K' (represents remaining exposures in excess of 1,000)

10 Flash-ready indicator

11 Number of exposures remaining / Number of exposures before the buffer fills / Preset white balance recording indicator / Exposure compensation value / Flash exposure compensation value / PC mode indicator

12 Auto ISO equivalency indicator

13 Electronic analogue exposure display / Exposure compensation value

14 Aperture

15 Battery level

16 In-focus indicator

LCD control panel

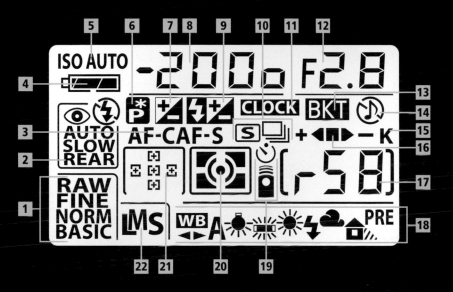

1 Image quality

2 Flash-sync mode

3 Autofocus mode

4 Battery level

5 Auto ISO equivalency indicator

6 Flexible program selected indicator

7 Exposure compensation selected indicator

8 Shutter speed / Exposure compensation value / Flash exposure compensation value / White balance adjustment / Number of shots (bracketing sequence) / ISO equivalency

9 Flash compensation selected indicator

10 Shooting mode

11 Clock battery indicator

12 Aperture / Auto-bracketing increment / PC mode indicator

13 Bracketing selected indicator

14 Beep-on / Beep-off indicator

15 'K' (represents remaining exposures in excess of 1,000)

16 Bracketing progress indicator

17 Number of exposures remaining / Number of exposures remaining in buffer / Preset white balance recording indicator / Nikon Capture 4 indicator

18 White balance mode

19 Self-timer / Remote control indicator

20 Metering mode

21 Focus area / AF-area mode

22 Image size

Operating the D70 command dials

The D70 uses main and sub-command dials, in isolation or in conjunction with other buttons to select and set various modes and functions. The following table illustrates each available operation.

Main command dial – by itself

1) Rotating when in shutter-priority auto or manual exposure modes will select the shutter speed.

2) Rotating when in auto multi program mode will perform 'flexible program' mode.

Main command dial – in operation with the following other buttons:	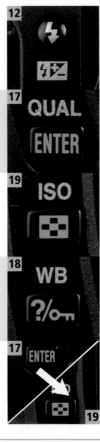 Selecting the flash-sync mode
Selecting the metering mode	Selecting the image quality (in shooting mode)
Selecting exposure compensation	Selecting ISO equivalency (in shooting mode)
Selecting auto-bracketing	Selecting the white balance setting
Selecting the shooting mode	Changing the size of the selected playback area (in playback mode)

Sub-command dial – by itself

Rotating when in aperture-priority auto or manual exposure modes will set the lens aperture (when used with CPU lenses, see page 184).

Sub-command dial – in operation with the following other buttons:

Selecting auto-bracketing program

Selecting flash exposure compensation

Selecting the image size

Fine-tuning the white balance

Note The functions of the main and sub-command dials can be switched using custom function number 14 (see page 116).

Multi selector

The multi selector on the rear of the camera is used to navigate the D70's menus, view playback images and select focus areas.

◀ ▶ Left and right arrows

Used to move the cursor or selected focus area left or right. Cancels or selects highlighted menu settings respectively. The right arrow can normally be used in place of the enter button. They also navigate the playback screen or display selected photo information.

▲ ▼ Up and down arrows

Move the cursor, selected menu setting, or selected focus point up or down. Used to navigate the playback screen or display the previous/next image respectively.

Chapter **2**

Operational guide to the D70

With such a long list of features it is easy to see what is exciting about getting your hands on a D70. In this chapter we're going to focus on getting you familiar with operating the camera and setting it up to suit your own style and needs. The D70 is a simple camera to operate but also has highly technical capabilities. The key to squeezing the most out of the camera is being able to control it in such a way that it adds to your creative vision and your ability to take the pictures you want.

Because the D70 has so many features it is easy to get caught up in all the technical wizardry it offers. However, all this sophisticated technology is only any use if you can control it properly.

Because of the technically advanced nature of the D70 many new users will find that their use of the camera grows with both their understanding of it and with the development of their photographic skills. In the early stages you may find yourself concentrating on some of the more practical, everyday operations of the D70. Then, as your skills and your vision develop, you will identify a need to gain a greater understanding of some of the more advanced features that the camera offers. Complementing your personal photographic development in this way is one of the main attributes of the D70.

The aim of this chapter is to act as your personal reference guide, to be revisited as the demands you make on your camera increase, and to complement your photographic development in a similar way to your D70.

Key to symbols used

The D70 offers so many different functions that it's difficult to get to grips with them all. To help I've divided them into three categories:

(S) **Start up** Functions used when setting up the D70

(B) **Basic** Functions or techniques that you will use on a regular basis

(A) **Advanced** Functions and techniques that you may use less often

Camera **preparation**

Attaching the camera strap Ⓢ

The camera strap should be attached securely using the two eyelets (**13**) on either side of the top plate.

Installing and removing the monitor cover Ⓢ

The monitor cover can be removed by gently pulling the cover forward from the bottom while holding the camera firmly. To install it again, insert the guide on the top of the cover into the slot above the monitor (and below the viewfinder eyepiece) and press the bottom of the cover until you hear it click into place.

To protect the monitor from dirt and scratching the cover should be kept on whenever possible.

Installing batteries Ⓢ

The D70 can use two types of battery: a rechargeable Nikon EN-EL3 (provided) or CR2-type lithium batteries (three required) using the MS-D70 battery holder supplied. For general use the Nikon EN-EL3 will keep the camera operating longer.

1) To install or replace the camera battery first turn off the D70.

2) Open the battery chamber by sliding the cover latch to the position marked ⊃ and lifting.

3) Insert the battery or battery holder and close the battery chamber cover, making sure it is securely fastened.

4) Once a new battery has been installed, turn on the camera and check the battery level indicator to ensure it is fully charged.

Checking battery power levels ⓢ

To check the remaining charge of any installed batteries, turn the camera on and check the battery indicator in the LCD control panel.

 Sufficient battery power for normal operation

 Battery is partially charged and will soon need to be replaced

 Battery is almost exhausted and should be replaced

 Battery is completely exhausted, or is installed improperly.

The clock battery ⓢ

The **DATE/TIME** function of the D70 is powered separately from the main camera functions by a rechargeable battery. This is recharged when the main camera battery is installed, or when the D70 is powered by an (optional) EH-5 AC power adaptor.

If the **CLOCK** icon flashes in the control panel then the clock battery is exhausted and the D70 will reset the calendar to its default values. Insert a fresh main battery, or connect to the mains to recharge the clock battery, then set the correct **DATE** and **TIME**, following the instructions on page 43.

Mounting a lens (S)

1) Remove the rear lens cap and the camera body cap and, with the D70 switched off, align the mounting indexes (white dots) on the camera body and the lens, then fit the lens into the bayonet mount. With the lens firmly in place, making sure not to press the lens release button, twist the lens counter-clockwise until it locks. You should hear a solid click as the lock engages.

2) Once the lens is locked, set the aperture to its minimum, (the largest number on the aperture index), via the aperture control ring, (only relevant for non-G-type CPU lenses).

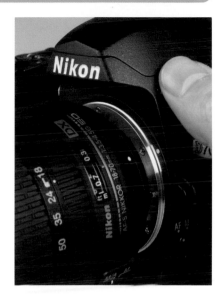

Removing a lens (S)

To remove a lens from the lens mount, press down and hold the lens release button (**5**) and, holding the lens by the barrel, turn it clockwise. Be sure to replace the rear lens cap before storing the removed lens to protect it from dust and scratching.

Note
While all Nikon lenses have used the f-mount bayonet since 1959 only certain lenses are fully compatible with the D70. Refer to the chart on page 184.

⚠ Common errors

If the control panel displays 'F--' instead of the aperture then the lens has not been attached properly. It is likely that the lens has not been locked in place completely, or that it is not set to the minimum aperture.

Tip
To help prevent dust from attaching to the low-pass filter, turn off the camera before changing lenses. Point the camera towards the floor so that dust doesn't settle on the CCD.

Inserting memory cards ⓢ

1) Images are stored on either a type I or II CompactFlash card or on a Microdrive. To insert a memory card, first turn off the camera.

2) Open the memory card holder cover (**30**) by sliding the latch (**31**) to the right and pulling it forward.

3) Insert the card, making sure it is the right way round. When the card is installed, the access lamp (**32**) will light and the card-eject button will protrude. Close the card slot cover.

4) Memory cards must be formatted for the D70 before they are used for the first time. See page 42.

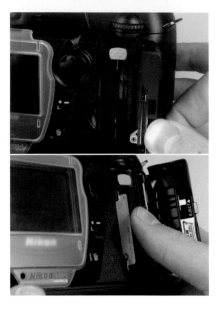

Notes

To avoid damaging the card, it should be inserted at a slight angle with the terminal pins facing the camera back and the front of the card facing towards the slot. Don't press too hard to install the card. If you encounter resistance check the card is in the correct position. Never force the card into place.

If the LCD control panel reads **[For]** then the card needs to be formatted, see page 42.

⚠ Common errors

If [CHR] appears in the control panel then the D70 is unable to read the memory card being used. Try formatting the card or switching to an alternative card to solve the problem.

Tip

Microdrives contain moving parts and these can cause excessive heat generation and power usage, as well as being comparatively fragile. Because of these shortcomings I prefer to use solid state CompactFlash cards.

Ejecting memory cards B

1) To eject a memory card wait until the green access lamp (**32**) switches off, then turn the D70 off. Open the memory card holder cover (**30**) and press the card-eject button. The memory card can then be slid out the rest of the way by hand.

2) When no memory card is inserted in the D70 the exposure count display will read [-**E**-].

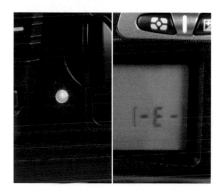

Powering on S

1) To turn the camera on, swivel the power switch (**38**) clockwise into the 'ON' position. The LCD control panel will power on and the viewfinder display will light up.

2) When the D70 is turned on for the very first time, the DATE menu and LANGUAGE menu are displayed on the monitor. To set the date, time and language refer to pages 40 and 43.

Notes

When turned off with a charged battery and memory card installed the control panel will still show the number of exposures remaining.

If the control panel remains blank the battery is exhausted.

Setting the viewfinder dioptre S

1) The viewfinder of the D70 can be adjusted to suit your sight. To set the dioptre, remove the eyepiece cup (**24**) and slide the dioptre adjustment control (**26**) until the focus brackets and viewfinder display appear sharp.

Using the **D70's menus**

Many of the D70's functions are accessed via the menu screens, which are displayed on the monitor on the back of the camera.

It is helpful to think of the camera's menus as a filing cabinet. The cabinet has four drawers and each represents one of the four menus. Within each drawer are folders (the menu options) and within each folder are files (sub-menu options). To access a menu option or a sub-menu option, you simply have to open the correct 'drawer' and access the right 'folder', then find the 'file' you want. Note that some menu items cannot be accessed in some modes, when the camera is recording data, or when no memory card is inserted.

To access the menus

1) Make sure the camera is turned on and press the **MENU** button (**20**) on the back of the camera body. The camera will display the last menu used on the monitor. To navigate around the menus and select options use the D70's multi selector (**29**).

The D70 has the following four main menus:

- ▶ Play
- 📷 Shooting menu
- ✎ CSM menu
- ⌥ Set up

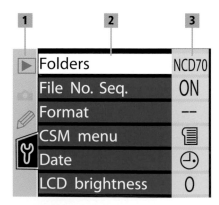

The main menu screen is split into three main sections:

1 The left column contains the four main menu folders

2 The middle column contains the menu options for the highlighted main menu folder

3 The right column contains the status of the menu item

To switch between the menu folders

1) Position the cursor in the left column. If the cursor is in the middle column when the menu screen is activated press the **MENU** button.

2) You can use the ▲ and ▼ arrows on the multi selector to highlight each of the main menu folders and the ◄ arrow to view the menu names.

3) To select a main menu folder, highlight it with the ▲ and ▼ arrows and use the ► arrow of the multi selector to position the cursor in the centre column.

4) To switch between menu options use the ▲ and ▼ arrows on the multi selector to highlight each of the options in turn.

5) Once you have highlighted the menu option to be viewed press the ► arrow of the multi selector to display the menu option settings and then use the ▲ and ▼ arrows of the multi selector to highlight the appropriate setting.

6) To select a setting press the ► arrow of the multi selector or press the **ENTER** button (some functions can only be activated by pressing **ENTER**). To exit the menu settings or the menu options without making a selection press the ◄ arrow of the multi selector, or press the **MENU** button (twice if the menu options column is highlighted) or press the ▶ button to take you to playback mode. See page 105.

Notes

Menu selections can be made by either pressing the ► arrow of the multi selector or by pressing the **ENTER** button. Throughout this text I refer to using the **ENTER** button as the means of making menu selections. However, either option can normally be employed. Unless the menu screen specifically tells you to use the **ENTER** button, such as when using the DELETE ALL function.

To access sub-menus, press the ► arrow of the multi selector from the menu settings screen.

If you do not press any buttons or perform any functions for 20 seconds the monitor will automatically switch off in order to preserve battery power. The length of the 'monitor off time' can be adjusted under custom setting 22, see page 119.

The SET UP menu

The SET UP menu controls 14 options that are used to control the basic parameters of how the camera operates.

Folders

The D70 manages images in folders. The FOLDERS menu option allows you to create new folders, rename existing folders, select a folder for storage, and delete empty folders.

Selecting folders

1) To select an existing folder for the D70 to use for image storage, choose the **SELECT FOLDER** menu option from the **FOLDERS** menu and press **ENTER**.

2) The names of existing folders will be displayed on the monitor.

3) Use the ▲ and ▼ arrows on the multi selector to choose a folder, press **ENTER** to select it. When a new picture is taken the D70 stores it in this folder until an alternative is selected. This folder will also be used for playback when **CURRENT** is selected in the **PLAYBACK FLDR** menu, see page 101.

Notes

If no new folders are created then the D70 will store images in the default folder, named NCD70.

The current folder is always displayed first in the list of folders, followed by the default folder (NCD70). Any additional folders are listed in alphabetical order.

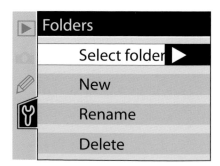

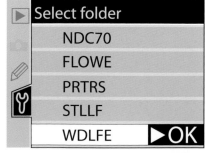

Creating new folders

1) To create a new folder, select the **NEW** menu option and press **ENTER**. An alphanumeric keypad will be displayed on the monitor.

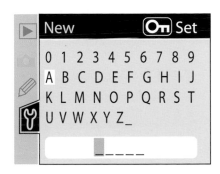

2) To name the folder, use the multi selector to navigate the keypad and highlight the appropriate character. To select a character press the **?/O** button. The name will be spelled out at the bottom of the display. Folder names can be five characters long. If you try to insert another character it will replace the one in fifth place.

3) To confirm creation of the new folder, press **ENTER**. This new folder will automatically become the current folder unless another folder is selected via the **SELECT FOLDER** menu option. It will also be used in playback if **CURRENT** is selected in the **PLAYBACK FLDR** menu.

Editing folder names A

1) To edit a folder name during creation, use the ⊞ button together with the main command dial to shift the cursor right and left. To insert a new character at the cursor position, use the multi selector to highlight the character and press the **?/O** button. To delete the character at the cursor position, press the 🗑 button.

2) Press **MENU** to return to the **SET UP** menu without saving the changes.

Note

The D70 automatically adds a prefix to the folder name when it is stored on the memory card. This extension takes the form of a three-digit number, for example 100NCD70. When each folder reaches its limit of 999 images, the camera creates a new folder of the same name but with a different three-digit folder number in a logical order, e.g. 101NCD70, 102NCD70, 103NCD70, etc. For the purposes of selection, naming and playback, all folders with the same name are treated as the same folder, irrespective of their prefix number. When new images are taken, the D70 stores them in the folder name selected by the user (or the default folder) and which has the highest folder number.

Renaming folders (A)

1) To rename an existing folder, select **RENAME** from the **FOLDERS** menu and press **ENTER**.

2) All existing folders will be listed and displayed on the monitor. Use the ▲ and ▼ arrows on the multi selector to specify a folder and press **ENTER**. The monitor will display a keypad and list the folder name at the bottom of the screen.

3) To edit the name, follow the instructions set out for EDITING on page 39.

4) Press **ENTER** to confirm and save the new folder name. To exit the **RENAME** menu without saving the new name, press **MENU**.

Deleting folders (A)

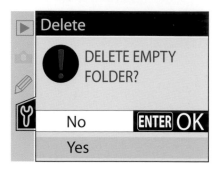

1) To delete a folder, first ensure that it contains no images.

2) Highlight **DELETE** in the **FOLDERS** menu and press **ENTER**.

3) To delete empty folders select **YES** and press **ENTER**. To exit the menu without deleting empty folders select **NO** and press **ENTER**.

Language (S)

The D70 can display the menu in a number of different languages. To select the language used, choose **LANGUAGE** from the **SET UP** menu and press **ENTER**. Use the multi selector (▲ and ▼ arrows) to select the language and press **ENTER** to confirm the language chosen.

Note

The language selection menu is shown when the camera is switched on for the first time. If the language is not confirmed then the language selection menu will appear again when the D70 is next turned on.

When a picture is taken, the D70 gives it a file number. The first image taken on a new D70 is numbered 0001. Subsequent images are numbered by adding 1 to the current number, so that the second picture will be numbered 0002, the third 0003, and so on.

The **FILE NO. SEQ.** menu option allows you to control how the sequencing continues when a new folder is created, the memory card is formatted or a new memory card is inserted into the D70.

1) To access this option, select **FILE NO. SEQ.** in the **SET UP** menu and press **ENTER**.

2) Choose one of the options in the table, right, by highlighting it using the ▲ and ▼ arrows on the multi selector and pressing **ENTER**.

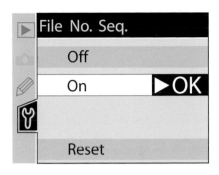

Option	Effect on file no.
OFF (default setting)	The file number is reset to 0001 whenever a new folder is created, when the memory card is formatted or when a new memory card is used.
ON	The D70 continues the numbering sequence from the last number used. If a picture is taken when the current folder contains picture number 9999, a new folder is automatically created and sequencing is reset to 0001.
RESET	Manually resets the sequencing to 0001 for the next photograph. If the current folder contains images then a new folder is automatically created.

Note
If the current folder is numbered 999 and contains 999 pictures or a photograph numbered 9999, the D70 automatically disables the shutter-release button until some memory is cleared.

Formatting memory cards Ⓢ

1) Memory cards must be formatted for the D70 before they are used for the first time. To format a memory card, install it in the camera. Turn the camera on and press **MENU**.

2) Select the **FORMAT** menu option in the **SET UP** menu and press the ▶ arrow on the multi selector. Select the **YES** option and press **ENTER**. The message **FORMATTING** will appear on the monitor and the message **'For'** and the number of exposures remaining will blink in the viewfinder and the LCD control panel. To cancel the process, press any other button.

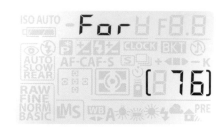

3) Nikon states that you can perform the same function by pressing the two **FORMAT** buttons (**23**) and (**42**) simultaneously for approximately two seconds. However, while the blinking **'For'** symbol appears, this did not format the card on either of the two D70's used in preparing this book.

Notes

Formatting a memory card will permanently erase any information already stored on the card, including hidden and protected images. Never remove the card, switch off the camera or disconnect the power supply during formatting.

The FAT 16 standard is used when formatting memory cards already formatted in FAT 16.

Formatting a card can be used as an alternative to the DELETE>ALL option in the PLAY menu.

Customizing your D70 Ⓐ

The D70 has nine primary custom settings and 16 advanced custom settings. You can determine whether only the primary (SIMPLE) custom settings plus R (**MENU RESET**) are displayed in the **CSM** menu or all 25 options (DETAILED) plus the **MENU RESET** are shown.

1) Select **SIMPLE** from the **CSM MENU** option and press **ENTER** to select only the primary settings. To show all custom function options select **DETAILED** and press **ENTER**.

For a full list of custom settings and their application, see page 110.

Setting date and time (S)

1) To set the date and time, select the **DATE** menu on the monitor press **ENTER** to access the date and time options. Using the multi selector set the appropriate date. (The ▲ and ▼ arrows will change the values, while the ◄ and ► arrows will switch between year, month, day, hour, minute and second).

2) Press **ENTER** to confirm the changes.

⚠ Common errors

If you fail to confirm the DATE selections by pressing ENTER you will need to repeat this process each time the camera is turned on before picture taking is permitted by the D70.

Notes

The DATE menu is automatically displayed when the D70 is turned on for the first time.

The camera clock is less accurate than most wristwatches and household clocks. Check the time regularly to ensure accuracy.

LCD brightness (S)

The brightness of the LCD monitor can be adjusted to suit your environment or personal preference.

1) Select **LCD BRIGHTNESS** in the **SET UP** menu and press **ENTER**. A grey scale will be displayed on the monitor (see above) as a visual guide to brightness levels. Use the ▲ arrow on the multi selector to increase or the ▼ arrow to decrease brightness. The default setting for the D70 is 0 and brightness can be adjusted between +2 (brightest) to –2 (darkest).

2) When you have set the desired level of brightness press **ENTER**.

Note
The LCD and the control panel may dim or brighten depending on the temperature.

Mirror lock-up ⓐ

The reflex mirror can be locked in the up position to enable access to the low-pass filter that covers the CCD.

1) Select **MIRROR LOCK-UP** in the **SET UP** menu and press ▐ENTER▌.

2) To lock-up the mirror select **YES** using the ▲ and ▼ arrows on the multi selector and press ▐ENTER▌. When **YES** is selected the mirror will be locked-up when the shutter-release button is pressed. The visual message "---- --" will be blink in the LCD control panel.

3) To return the mirror to the down position, turn the D70 off.

4) When **NO** is selected from the **MIRROR LOCK-UP** menu the mirror operates normally.

Tip
Never use mirror lock-up when the camera is low on battery power or not connected to an EH-5 AC adapter, otherwise the mirror may fail to return to its normal position when the camera is turned off.

Note
The mirror lock-up function on the D70 is not the same as on a number of other cameras. Lock-up is intended to enable access to the low-pass filter, whereas with many other cameras it is used to minimize camera shake.

Video mode ⓐ

Before connecting the D70 to a video device such as a television set or video recorder, set the video mode to match the standard used in the device.

Highlight **VIDEO MODE** in the SET UP menu and press ▐ENTER▌. Choose either **NTSC** or **PAL** depending on the standard of the device you are connecting to and press ▐ENTER▌ to set the standard used. See page 203 for more on connecting to a television.

Note
The standard mode on most televisions or video recorders depends on the region of the world. There will be a slight reduction in resolution when connecting the D70 to a PAL standard device.

Image comment

When you take a picture with the D70 you can are append comments to the image file for later viewing in Nikon View or PictureProject (supplied) or Nikon Capture 4 version 4.1 or later (optional) software.

Adding/editing comments

1) To append a text comment to an image, select **IMAGE COMMENT** from the **SET UP** menu and press **ENTER**.

2) Use the ▲ and ▼ arrows on the multi selector to choose an option and press **ENTER**.

3) To input a new comment to a single image select **INPUT COMMENT** and press **ENTER**. An alphanumeric keypad and comment area will be displayed on the monitor (see above right).

4) To add or edit a comment, use the ⊞ button together with the main-command dial to shift the cursor within the comment area. To insert a new character at the cursor position, use the multi selector to highlight the character and press the **?/On** button. To delete the character at the cursor position, press the 🗑 button.

Comments can be up to 36 characters in length. Any characters added after the 36th will be deleted.

5) To confirm the comment press **ENTER**, highlight the **DONE** menu

option in the **IMAGE COMMENT** menu and press **ENTER**.

6) To exit the **IMAGE COMMENT** menu without appending the message, press **MENU**.

Appending a comment to all pictures

1) To add the latest comment to all subsequent pictures check the box next to the **ATTACH COMMENT** menu option by highlighting **ATTACH COMMENT** and pressing **ENTER**. A tick symbol will appear next to the **ATTACH COMMENT** option. Highlight **DONE** in the **IMAGE COMMENT** menu and press **ENTER** to confirm the selection.

2) To deselect the **ATTACH COMMENT** menu option, highlight it and press **ENTER**. The tick mark will disappear. Highlight **DONE** in the **IMAGE COMMENT** menu and press **ENTER** to confirm the selection.

The USB connection type must match the device and software being used in conjunction with the D70. The appropriate setting should be selected before the D70 is attached to the printer or computer. When using the D70 with a PictBridge printer or when using the Camera Control in Nikon Capture 4 (optional) software, the D70 should be set to the PTP setting.

When using the Nikon View (supplied) software to transfer images to a computer the USB setting should be set according to the table below.

1) The default setting for USB is **MASS STORAGE**. To change the setting, highlight **USB** in the **SET UP** menu and press [ENTER].

2) Use the ▲ and ▼ arrows of the multi selector to highlight either **PTP** or **MASS STORAGE** in menu options and press [ENTER].

Operating system	Option
Windows XP Home Edition Windows XP Professional Mac OS X	Select **PTP** or **MASS STORAGE**
Windows 2000 Professional Windows Millennium Edition (Me) Windows 98 2nd Edition (SE) Mac OS 9	Select **MASS STORAGE**

⚠ Common errors

Some early batches of the D70 are set to PTP as their default USB option.

Note

PictBridge is a photographic industry standard that enables photographs to be printed directly from the D70 to a printer without having to connect to a computer. See page 204.

Dust that has accumulated on the low-pass filter that covers the CCD can cause unsightly marks on pictures. To reduce the effects of dust the D70, in conjunction with (optional) Nikon Capture 4 (version 4.1 or later) software, compares a RAW image with a reference image created by the D70.

For this advanced function to work a number of rules must be adhered to:

a) Both the reference image and the RAW image must be taken on the same camera.

b) The image quality must be set to RAW, see page 52 for how.

c) The optional software Nikon Capture 4 v. 4.1 or later must be used.

d) The reference image must be taken using a CPU-type lens, see page 184.

1) Attach a CPU-type lens to the D70. For the best results use at least a 50mm lens. Set zoom lenses to their maximum focal length setting.

2) In the **SET UP** menu highlight **DUST REF PHOTO** and press **ENTER**. To exit the menu without taking a reference image select **NO** and press **ENTER**.

3) To take a reference image, highlight **YES** and press **ENTER**. The D70 will automatically adjust the image

⚠ Common errors
If the message 'EXPOSURE SETTINGS NOT APPROPRIATE' appears on the monitor then the reference object is too dark or too light. Choose another object and follow the steps above.

settings for image dust off and the message 'rEF' will appear in the control panel and viewfinder. The message '**Take photo of white object 10cm from lens**' will appear on the monitor.

Dust ref photo

Take photo of
white object
10cm from
lens.

4) If the camera is set to manual focus mode, set the focus to infinity. In autofocus mode the D70 automatically sets focus to infinity when the shutter-release button is semi-depressed.

5) Position the lens 4in (10cm) from a featureless white object and frame it so that the image space is filled (remember that the viewfinder of the D70 only displays 95% of the image space).

6) Press the shutter-release button fully to take the reference image.

Firmware ver (version)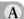

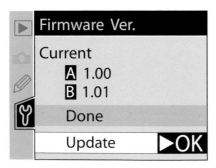

New firmware will be released to improve the performance of the D70, this can be downloaded from Nikon Web-sites, see page 218. To update the current version first download it to computer and transfer to a memory card, insert the card (see page 34), highlight **FIRMWARE VER** in the **SET UP** menu and press [ENTER]. Select update, then **YES** and press [ENTER].

Image rotation 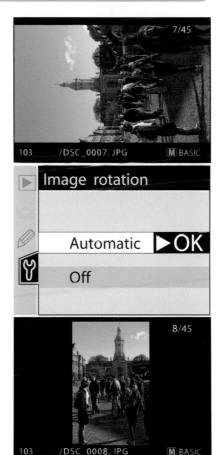 **S**

The D70 can detect the orientation of the camera when shooting so that images are displayed on the monitor or in Nikon View or Nikon Capture 4 version 4.1 or later software in the correct orientation.

In the D70's default setting, orientation detection is automatic. However, when the camera is pointing straight down or up, it may be preferable to turn image rotation off.

1) To change image rotation settings, highlight **IMAGE ROTATION** in the **SET UP** menu and press 𝗘𝗡𝗧𝗘𝗥.

2) To turn image rotation off, select **OFF** in the menu options using the ▲ and ▼ arrows of the multi selector. Press 𝗘𝗡𝗧𝗘𝗥 to confirm the selection.

3) To turn image rotation on, select **AUTOMATIC** in the menu options using the ▲ and ▼ arrows. Press 𝗘𝗡𝗧𝗘𝗥 to confirm the selection. In **AUTOMATIC** mode the D70 will detect vertical orientation in both clockwise and anticlockwise directions.

Note
The image will only be rotated on the monitor if **YES** is selected in the **ROTATE TALL** menu option in the **PLAY** menu, see page 101.

Tip
When the camera is set to continuous servo mode the orientation of the first picture dictates the orientation of all subsequent pictures taken during that burst.

Setting **image parameters**

There are some additional elements in digital photography that need to be addressed before you take a photograph that do not apply to film cameras. These functions may make using a digital camera in the first instance seem more daunting, but ultimately they provide you with much greater flexibility than when shooting film. It is well worth taking the time to understand how each of them affects image quality and how they can be exploited to give you greater flexibility in the field.

The SHOOTING menu

The shooting menu is used to control six basic image parameters. Choosing between the available variables in each parameter is a key part of the photographic decision-making process before you press the shutter-release button.

Image quality

The D70 can record images in a number of different quality settings depending on how you intend to use the final photograph. The difference between RAW and JPEG files is far more complex than simply one of quality versus file size. In essence RAW files are unprocessed data, and although the D70 compresses its NEF files this compression system is lossless so all the basic raw information is still present. Shooting in JPEG is often the most practical as the quality is still high in JPEG Fine mode, and the files are smaller with faster write times. However, if you find that your D70 is being pushed to the limits by difficult lighting conditions or you want to do a lot of work on the image at a later stage, switching to RAW can help to improve image quality.

Try shooting a few trial images using the RAW + JPEG Basic option. Then compare the two images in an application such as Photoshop. Once you have determined the limits of JPEG files you can make an informed decision on which option to choose.

Option	Description
RAW – NEF	Lossless compression applied – the image is compressed to reduce size but no data is discarded: when the file is opened all the original data is displayed. High-quality, high-resolution image. Must be opened in Nikon View, PictureProject (supplied) or Nikon Capture (optional) software. Plugins are available for other applications.
JPEG Fine	Low ratio (1:4) of compression applied. The image is compressed to reduce file size and little original data is discarded. When the file is opened the computer will interpolate from the remaining original data to display the image. High quality, suitable for enlargement and photo-quality printing. Can be opened in most image processing software packages.
JPEG Normal	Medium ratio (1:8) of compression applied. The image is compressed to reduce file size and some original data is discarded: when the file is opened the computer will interpolate from the remaining original data to display the image. Good quality, suitable for photographic prints with minimal enlargement from the original. Can be opened in most image processing software packages.
JPEG Basic	High ratio (1:16) of compression applied. The image is compressed to reduce file size and some original data is discarded: when the file is opened the computer will interpolate from the remaining original data to display the image. Basic quality, suitable for sending images via e-mail and uploading to a web-site. Can be opened in most image processing software packages.
RAW + JPEG Basic	Two images are recorded, one RAW image and one basic-quality JPEG image (see above comments). Image size is automatically set to large. When viewing images on the D70, the JPEG file is the image viewed. The unprocessed images can be transmitted via e-mail quickly, but you still retain a high-quality image. Must be opened in Nikon View, PictureProject (supplied) or Nikon Capture 4.1 or later (optional) software. Plugins are available for other applications. When deleted in-camera, both images are deleted.

1) To select image quality via the menu, go to the **SHOOTING** menu and select **IMAGE QUALITY**. Use the ▲ and ▼ arrows on the multi selector to highlight the required setting and press `ENTER`.

2) To use the **QUAL** button (**17**), wait until the monitor is off and press `ENTER`. Simultaneously rotate the main command dial until the required setting appears in the control panel.

Notes

The D70 cannot record images in TIFF format. To obtain TIFF files set the file type to RAW (NEF) and transfer the images to computer, then save them as TIFFs.

The D70 doesn't offer the option of recording uncompressed NEF files as the compression and processing system is fast and lossless, making uncompressed NEF files redundant.

⚠ **Common errors**

Each time you save a JPEG file it loses a little more quality, depending on the level of compression. If you intend to do a lot of work on a JPEG, first save it as a lossless TIFF file, and keep the original JPEG for reference.

Tips

The RAW setting has the advantage of allowing post-capture changes to be made to the image as if they had been made in-camera at the time of shooting. A RAW image also cannot be overwritten; meaning you will always have an original file to revert back to.

It is generally best to select the largest file size as it gives greater flexibility of use of the image later on. The main reason for limiting file size is to reduce use of storage space. However, with today's mass storage availability both on memory cards and in computers this is becoming less of an issue.

Large capacity memory cards can store thousands of low-resolution images on a single card but your pictures are vulnerable to loss or damage. It is better to have fewer images in one place to reduce the risk, in other words don't put all your eggs in one basket!

If you don't have a computer with you and your memory card fills up consider using a portable storage device, for example the Nikon Coolwalker see page 194.

Selecting image size 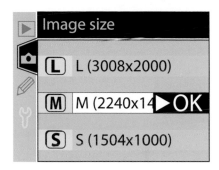 **B**

1) In the menu go to the **SHOOTING** menu and select **IMAGE SIZE**. Use the ▲ and ▼ arrows on the multi selector to highlight the required setting and press **ENTER**.

When the monitor is off, image size can also be selected by depressing the **QUAL** button (**17**) and simultaneously rotating the sub-command dial.

2) Your selected image size will be displayed in the control panel.

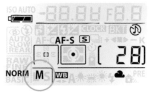

The size of an image is measured in pixels and the general rule is the greater the number of pixels the better the image quality. The smaller the image size the smaller the file size in megabytes, which makes transmission via e-mail or over the web quicker. The larger the image size the larger prints can be made without degrading image quality. The D70 gives three options, as outlined in the table below:

Option	Size (pixels)	Printed size at 200 dpi (approx)
Large	3,008 x 2,000	15 x 10 inches (38 x 25cm)
Medium	2,240 x 1,448	11 x 7½ inches (28 x 19cm)
Small	1,504 x 1,000	7½ x 5 inches (19 x 13cm)

Note
When using the D70, you'll notice that the medium image size requires longer to process than large file sizes. If the space available on the memory card is not an important issue (see page 54) and processing speed is, it is better to select large file sizes.

Memory card capacity with the D70

The D70's dynamic memory buffer allows it to process images while shooting continues. This means that although the control panel might indicate a number of shots left in the buffer's capacity the actual number you are able to take before shutter-lock-out occurs is likely to be greater than this, although by how much depends on the memory card you use.

Note
When high-capacity memory cards are used the number of images available may run into thousands. When this is the case the figure in the D70's control display and viewfinder will display a K to represent '000's, rounded down to the nearest 100. For example 1,830 images will be shown as 1.8K

Image quality	Image size	File size (MB)	No. of images per 256mb card	Buffer capacity
NEF (RAW)	N/A	5.0	23	4
JPEG Fine	L	2.9	73	9
JPEG Fine	M	1.6	130	7
JPEG Fine	S	0.8	279	19
JPEG Normal	L	1.5	144	12
JPEG Normal	M	0.8	253	7
JPEG Normal	S	0.4	528	27
JPEG Basic	L	0.8	279	19
JPEG Basic	M	0.4	481	7
JPEG Basic	S	0.2	950	49
NEF + JPEG Basic	L (JPEG)	5.8 (total)	21	4

These figures are approximate, the exact numbers being dependent on the scene photographed.

Setting ISO-E (equivalency) Ⓑ

The sensitivity of the CCD is measured by an ISO-E rating. The greater the sensitivity of the sensor (the higher the ISO-E) the less light is needed to record an image. However, higher ISO ratings display greater noise, see page 70. One advantage of the D70 is that you can vary the ISO-E from shot to shot, or you can leave the D70 to decide. The D70 has an ISO-E range of 200 (medium/slow) to 1,600 (fast) selectable in 1/3 stop increments. The range is: 200, 250, 320, 400, 500, 640, 800, 1000, 1250 and 1600.

ISO-E can be selected via the menu or using the ISO button (**19**).

1) In the menu, go to the **SHOOTING** menu and select ISO. Use the ▲ and ▼ arrows on the multi selector to highlight the required setting and press **ENTER**.

2) To use the ISO button, wait until the monitor is off and press **▣**. Simultaneously rotate the main command dial until the required setting appears in the control panel.

Tip
When shooting at an ISO-E rating greater than 400 I would advise turning on the Noise Reduction function (see page 70).

Notes

The D70 only reaches as low as ISO 200. However, the quality of the CCD negates the need for slower speeds that are traditionally used to reduce grain or noise. The ability of the D70 to shoot at speeds of up to 1/8,000sec enables wide apertures to be used at ISO 200 without the [HI] exposure warning flashing in the control panel.

The relatively large size of the pixels on the CCD gives them a greater light-gathering power than smaller ones, this makes slower ISO equivalent ratings unnecessary.

While the D70 displays some noise at high ISO levels it is 'good noise', if there is such a thing. Unlike some comparable digital SLRs the D70's noise characteristics are fairly even and rarely result in significant specific discolouration.

ISO Auto

The D70 comes with an ISO Auto function that, when selected, will leave the choice of ISO-E rating to the camera, see page 112.

White balance

The colour temperature of light depends on its source and external conditions. For example, at midday sunlight has a bluish cast, while early in the morning or late in the afternoon it has a warmer (orange/red) feel to it. Our eyes and brain adjust automatically to these changes so we normally perceive light as neutral.

The D70 provides a function that mimics these adjustments, known as white balance (WB).

Using the right white balance setting will give your pictures a natural colouring. Note that white balance can only be selected when the camera is set to **P**, **S**, **A** or **M**. The table gives some guidelines to setting white balance:

	Option	Approx. colour temp. (Kelvin)	Description
A	Auto	3,500–8,000K	WB is set by the D70. To get the most from Auto WB use a G- or D-type lens.
	Incandescent	3,000K	Use under incandescent lighting, such as household lamps and street lighting.
	Fluorescent	4,200K	Use under fluorescent lighting, such as strip lighting and stadium lighting.
	Direct sunlight	5,200K	Use with subjects lit by direct sunlight (cloudless day).
	Flash	5,400K	Use with lighting from a flash unit (including the built-in Speedlight).
	Cloudy	6,000K	Use on overcast days or when using diffused natural daylight indoors.
	Shade	8,000K	Use outdoors or indoors under natural light when the subject is in shade.
PRE	Preset	N/A	Use a white object to measure WB setting for specific lighting conditions (see page 59).

Tip

Auto white balance is effective in most situations but I have found that for landscapes in particular it produces images with a cool colour cast. The CLOUDY setting will produce warmer colours.

⚠ Common errors

The D70's Auto white balance mode may not work correctly in conjunction with the AS-15 hotshoe adaptor. Set the white balance to Flash and fine-tune if necessary.

Selecting white balance B

The WB can be selected via the menu or using the ?/⊙ button.

1) In the menu, go to the **SHOOTING** menu and select **WHITE BAL**. Use the ▲ and ▼ arrows on the multi selector to highlight the required setting and press ENTER.

2) To use the ?/⊙ button, ensure that the monitor is off and press the ?/⊙ button. Simultaneously rotate the main command dial until the required setting appears in the control panel.

⚠ Common errors

When you are selecting a white balance setting, remember that there is a difference between accurate and attractive images. Setting the white balance to the actual condition may not result in the most appealing results so try experimenting.

WB fine-tuning B

Once you have selected a WB setting (except **PRESET**) the D70 allows you to fine-tune it to compensate for slight variations in the colour temperature or to add a warmer (red) or cooler (blue) colour cast to the final image.

1) To fine-tune WB, select a WB setting other than **PRESET** and press ▶ on the multi selector. The WB fine-tuning display will appear on the monitor.

2) Use the ▲ and ▼ arrows on the multi selector to set the fine-tuning value then press ENTER.

3) WB can also be fine-tuned via the ?/⊙ button. Make sure the monitor is off and press the ?/⊙ button and simultaneously rotate the sub-command dial until the relevant value is shown in the control panel.

4) If a figure other than 0 is entered then the ◀▶ icon will appear in the control panel.

Note

Over-compensating (+) the WB will add a blue tint to pictures and should be used to reduce the yellow or red cast of some light sources (such as a household light bulb). Under-compensating (−) the WB will add a warm yellow or red tint that will nullify the blue cast from cool light sources (such as the midday sun). Adjustments can be made in the range of +3 to −3 in increments of 1, each incremental change being roughly equivalent to 10 mired, see note on page 62 (except in **FLUORESCENT** mode).

Colour temperature

Colour temperature is an objective measure of the colour of a light source, measured in degrees Kelvin (K). White light has a temperature of around 5,000–5,500K. Below this temperature light will appear 'warm', having a red or yellow tint, as you would expect to see during sunrise and sunset. Above 5,500K light takes on a 'cool' blue cast.

APPROXIMATE COLOUR TEMPERATURES (K) FOR PROGRAMMED WB SETTINGS WITH FINE-TUNING APPLIED

	Incandescent	Fluorescent	Direct sunlight	Flash	Cloudy	Shade
+3	2,700	2,700	4,800	4,800	5,400	6,700
+2	2,800	3,000	4,900	5,000	5,600	7,100
+1	2,900	3,700	5,000	5,200	5,800	7,500
0	3,000	4,200	5,200	5,400	6,000	8,000
−1	3,100	5,000	5,300	5,600	6,200	8,400
−2	3,200	6,500	5,400	5,800	6,400	8,800
−3	3,300	7,200	5,600	6,000	6,600	9,200

Using the preset WB function

As well as the programmed and auto WB settings the D70 allows you to preset WB for difficult lighting conditions, where there is mixed lighting or lighting with a very strong colour cast. This is a useful tool if you are able to guarantee the lighting conditions that you are shooting under.

The D70 will only store a single preset WB value. Each time a new value is measured it will overwrite the existing value in the D70. There are two ways of saving a preset white balance. The first, measuring white balance, is useful for set circumstances where you have full control of the lighting or know that it will not change, such as in a studio. The second, copying from an existing photograph, is best used when you are revisiting a certain situation that you have already achieved favourable results in photographing. Both methods are described in full below.

Measuring for WB

1) First, place a white or medium grey object in the light you'll be photographing in. From the D70's menu, select the **MEASURE** option in the **PRESET** menu option or press the **?/On** button and simultaneously rotate the main command dial until **PRE** is shown on the LCD control panel. Release the **?/On** button briefly and then press it again until the **PRE** icon begins to flash in the LCD control panel and the viewfinder display.

2) Frame the reference object so that it fills the image space and fully depress the shutter-release button. Remember that the viewfinder only shows 95% of the image that will be captured, so ensure that the object overlaps the viewfinder frame somewhat. The camera will record the WB for the lighting conditions; note that the D70 will only record the WB settings, it will not take a photograph. If you change your mind and do not want to record a white balance, press the WB button before depressing the shutter-release button, to exit the menu.

3) If the icon **GOOD** displays in the control panel then WB has been measured successfully. If, however, the lighting was too dark or too bright the message **no Gd** will appear in the control panel. Try adjusting the level of lighting and repeat the process.

4) Once you have completed the process you can return to shooting mode by semi-depressing the shutter-release button.

Note
The D70 will only store a single preset WB value. Each time a new value is measured it will overwrite the existing value in the camera. No image will be recorded during this process and WB will be recorded accurately even when the subject is out of focus.

Copying WB from an existing photograph Ⓐ

As well as measuring it from a grey or white object you can copy a WB value from an existing image on your memory card. This is useful if you have achieved good results under certain lighting that is likely to recur. Only pictures taken with the D70 can be used as the source image for setting WB.

1) From the **PRESET** menu option in the **WHITE BAL.** menu, select the **USE PHOTO** option. Select the **SELECT**

IMAGE option and choose the relevant picture folder that contains the source image using the ▲ and ▼ arrows on the multi selector, select it by pressing **ENTER**. Highlight the picture that is to be the source picture and press **ENTER**.

2) Highlight **THIS IMAGE** in the menu and press the ▶ arrow on the multi selector. Preset WB will now be set to the same value as the source image.

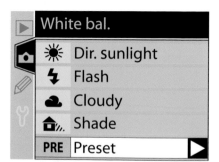

Tip
You can use the existing preset WB value at any time by selecting **PRESET > MEASURE > ENTER** from the **WHITE BAL.** menu.

WB bracketing

Later on I mention bracketing to help ensure correct exposure of an image, see page 93. The D70 can also bracket images for correct WB. WB bracketing operates differently to exposure bracketing (which takes a number of separate images) in that it only takes one image but processes it differently to achieve the brackets. This is useful for difficult lighting situations where the white balance is hard to judge, or for situations were the lighting conditions change rapidly.

White balance bracketing is also very useful if you have to shoot in JPEG mode as you cannot correct colour casts in JPEG mode easily on computer.

Selecting WB bracketing Ⓑ

1) Set image quality to JPEG Fine, JPEG Normal or JPEG Basic. WB bracketing will not function in RAW or RAW + JPEG modes.

2) In the Custom Settings menu, choose **CS 12** and select '**WB bracketing**' using the multi selector.

3) Once you have selected WB bracketing press the **BKT** button and simultaneously rotate the main command dial until **BKT** appears in the control panel. The ◄► icon will also appear and the arrows on the electronic analogue exposure display in the viewfinder will also blink.

4) To select the level and sequence of bracketing, press the **BKT** button and rotate the sub-command dial until the relevant program is indicated by the progress bars.

WB BRACKETING OPTIONS AVAILABLE:

Display	No. of shots	WB	Bkting order
3F1 +◄■►–	3	±1	±0, –1, +1
3F2 +◄■►–	3	±2	±0, –2, +2
3F3 +◄■►–	3	±3	±0, –3, +3
-- 2F1 ■►–	2	–1	±0, –1
-- 2F2 ■►–	2	–2	±0, –2
-- 2F3 ■►–	2	–3	±0, –3
+2F1 +◄■	2	+1	±0. +1
+2F2 +◄■	2	+2	±0, +2
+2F3 +◄■	2	+3	±0, +3

Each increment in the bracketing sequence is roughly equivalent to 10 mired. For example, selecting the ЭF2 +◄■►– WB bracketing program will produce three images at ±0 mired, –20 mired and +20 mired.

Cancelling WB bracketing Ⓑ

1) To cancel WB bracketing, press the **BKT** button and simultaneously rotate the main command dial until **BKT** disappears from the control panel.

Tips

WB bracketing will be cancelled if you select either the RAW or RAW+JPEG modes.

When WB bracketing is reactivated the last program that was selected will be restored.

If the D70 is turned off during white balance bracketing it will not switch off until the last image in the sequence has been written.

WB bracketing cannot be performed at the same time as exposure bracketing, see page 93.

The bracketing order can be changed in the **CSM** menu, see page 116.

Notes

A change in the colour temperature by a set value of Kelvin will have a greater effect at low colour temperatures than at high colour temperatures. To take this into account, changes in colour temperature are referred to as 'mired'. This mired value indicates the actual change in colour rather than in colour temperature.

Once you have selected a WB bracketing program, compose and take the picture. The D70 will take a single image (even if **CONTINUOUS SHOOTING** mode is selected) and process the image to produce the number of shots set in the WB bracketing program, each shot having a different WB.

Adjustments in WB set in the bracketing mode will be in addition to any manual adjustments made in the WB fine-tuning menu option.

If the number of shots selected in the WB bracketing mode exceeds the number of exposures available on the memory card, the control panel and viewfinder will display **FULL** and the exposures remaining indicator will blink. Inserting a new memory card or deleting some images will rectify the problem.

In-camera image processing

Unlike film photography where all the image processing takes place outside of the camera, the D70 enables some in-camera processing to take place.

When a vari-program is set, the D70 automatically adjusts the image processing settings for the scene being photographed. When the **P, S, A** or **M** modes are selected you can alter the image processing settings manually via the menus.

⚠ Common errors

Although good quality, the D70's monitor is often not the best place to judge image parameters. Shooting in the RAW NEF format will allow you to judge these factors more accurately on a computer screen.

PRE-DEFINED OPTIMIZATION SETTINGS
Pre-defined optimization settings can be selected via the **SHOOTING** menu by selecting **OPTIMIZE IMAGE**. The options below are available:

	Option	Description
N	Normal (default setting)	Normal processing of images applies.
VI	Vivid	Enhances saturation, contrast and sharpness to produce vibrant colours and well-defined detail.
SH	Sharper	Sharpens edges.
SF	Softer	Softens edges to give a smooth, natural reproduction of skin tones.
DP	Direct print	Use when images are to be sent directly from the camera to a connected printer.
PO	Portrait	Contrast is reduced and background details softened. Skin tones have a smooth, flattering, natural look.
LA	Landscape	Increases saturation of colours and sharpens outline details to produce vivid landscape images.
Custom	Custom	Allows manual adjustment of individual optimization settings.

Notes

As the image optimization applied by the D70 differs with every scene, results will vary depending on both conditions and exposure settings, unless the optimization values are set manually, see below.

When any of the pre-defined settings are selected, images are recorded in the sRGB colour space (see page 68).

Selecting a pre-defined image optimization setting Ⓐ

1) From the **SHOOTING** menu, select **OPTIMIZE IMAGE** and use the ▶ arrow on the multi selector to open the sub-menu. Highlight the option required and press **ENTER**.

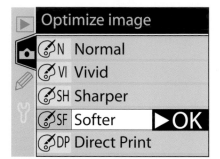

Manually adjusting image optimization Ⓐ

1) To set your own levels of image optimization select the **CUSTOM** option from the **IMAGE OPTIMIZATION** menu and use the ▶ arrow on the multi selector to open the **CUSTOM** sub-menu. Use the ▲ and ▼ arrows on the multi selector to highlight the required option and press the ▶ arrow on the multi selector to display the sub-options.

2) Use the table on page 65 to set the required level of optimization for each option. When you have selected the required level of optimization, press **ENTER** to save the changes and move on to the next setting.

Image sharpening

Controls the appearance of borders between light and dark areas of the picture. Be careful using in-camera sharpening, the results can look very seductive on the monitor, however over-sharpening is much harder to correct on computer than under-sharpening.

	Option	Description
A	**Auto** (default setting)	The D70 automatically sets the level of sharpening depending on the scene
◇ 0	**Normal**	Images are sharpened by the standard amount, used in most situations and conditions
◇ −2	**Low**	Sharpening is reduced from the standard amount. Used when soft edges are required
◇ −1	**Medium low**	Sharpening is only slightly reduced from the standard amount, giving slightly softer edges
◇ +1	**Medium high**	Sharpening is slightly increased from the standard amount, giving subjects a marginally harder edge
◇ +2	**High**	Sharpening is greatly increased from the standard amount, giving subjects a well-defined edge. Useful in landscape and architectural photography
✎	**None**	No sharpening is applied

⚠ Common errors

If the D70 is experiencing problems with aliasing/moiré (see page 171) then turn sharpening to its lowest amount, as this can help to relieve it.

Tip

I prefer to shoot with sharpening set to medium high, rather than the default setting of auto. Because auto changes from shot to shot you have very little control over sharpening, while using medium high suits most of my images. I shoot in the RAW NEF format so that I can adjust sharpening, if necessary, in application.

Tone compensation

Controls contrast by adjusting the distribution of tones in the picture using curves. This is a useful menu for images that will be used as they are recorded. However, for the reasons I stated previously (that image optimization settings are difficult to judge using the monitor) I use the D70 in normal tone mode. Because I have the back-up of large memory cards and portable storage devices I shoot in RAW NEF format, leaving any tinkering with contrast to a later stage.

	Option	Description
A	Auto (default setting)	The D70 automatically sets the contrast curve depending on the scene
◑ 0	Normal	The D70 uses a standard curve for all images that is suitable for general photography
◑ –2	Low contrast	The image is softened to prevent small areas of highlight from being rendered without detail. Particularly suitable for portrait photography
◑ –1	Medium low	Uses a curve that produces a level of contrast marginally less than normal setting
◑ +1	Medium high	Uses a curve that produces a level of contrast marginally greater than normal setting
◑ +2	High contrast	The camera sets a curve that increases the level of contrast. Can be used to preserve detail in hazy and misty conditions
◑ ✏	Custom	Allows you to define a custom curve in Nikon Capture 4 software (optional) and download it to the D70

Saturation

Saturation controls the vividness of colours and is the exception to the rule because I find it useful to choose this on-camera as I find it easy to judge what is required. Just think about how you want the final image to appear. Wildlife and landscapes can be improved by the enhanced colour saturation mode.

Tip
The enhanced option is useful when photographing landscape scenes, when the effect is similar to that of using a very saturated film, such as Fuji Velvia, in film-based photography, and when reproducing the image without any further enhancement.

Option		Description
⊛ 0	Normal (default setting)	The D70 reproduces natural-looking colours
⊛ −	Moderate	Reduces the vividness of colours. This option is generally only used when images will be heavily enhanced on a computer
⊛ +	Enhanced	The D70 enriches the colours to make them more vivid

Hue adjustment

Digital cameras produce colour by adding two or three colours together. For example, taking the three colours used in digital image-capture – red, green and blue – mixing equal parts of red and blue will give you magenta. By adding various combinations of red, green and blue light, all the colours of the visible spectrum can be created.

The hue control function of the D70 allows you to add an amount of colour cast in a range of −9° to +9° in increments of 3°. Red is the base colour (0°) and raising the level of hue above 0° will add a yellow cast making colours that start off as red appear increasingly more orange (mix red and yellow and you get orange). Reducing the level of hue will add a blue cast resulting in reds becoming purple. The greater the degree of change the stronger the affect.

1) To adjust the level of hue go to the **HUE ADJUSTMENT** option in the **CUSTOM** sub-menu of the **OPTIMIZE IMAGE** sub-menu and press **ENTER**. Use the ▲ and ▼ arrows on the multi selector to make the required level of adjustment. To confirm the setting press **ENTER**.

⚠ Common errors

Again you should be cautious when using hue and saturation controls. What may look attractive on the monitor may look false when displayed on a computer screen or even when printed.

Colour mode

Different devices operate with a varying gamut of colour; this is one of the reasons that the same image displayed on different monitors may appear differently. International Colour Convention (ICC) profiles are employed as a standard of colour. There are two main ICC profiles, Adobe RGB and sRGB, and both have their uses. Adobe RGB offers a wider colour gamut than sRGB and is the standard for print use and image manipulation. sRGB is particularly recommended for web publishing. The D70 allows you to select either Adobe RGB or two versions of sRGB, whichever best matches your needs.

	Option	Description
I	Ia (sRGB) (default setting)	Images are adapted to the sRGB colour space with colours matched to produce natural-looking skin tones without further computer modification. Use when photographing portraits.
II	II (Adobe RGB)	This setting matches the colour space with the Adobe colour space that has a wider gamut of colours than sRGB. Use this setting when further computer processing is anticipated.
III	IIIa (sRGB)	As for setting Ia, images are adapted for the sRGB colour space, except colours are matched to produce vivid nature and landscape images.

Choosing the shooting mode

The D70 can be operated in five different manually selectable shooting modes to suit the subject being photographed.

To select a shooting mode, press the ▣ button and simultaneously rotate the main command dial until the appropriate icon is displayed.

	Mode	Description
S	Single frame	The D70 exposes a single frame when the shutter-release button is pressed. Subsequent shots can be taken immediately if enough buffer space is available. Suitable for most forms of photography.
▣	Continuous	The camera will record up to three frames per second while the shutter-release button remains fully depressed and until the buffer fills. Ideal for capturing action sequences.
⟳	Self-timer	Using the self-timer delays the activation of the shutter by between two and 20 seconds (see page 120) after the shutter-release button is pressed. Suitable for self-portraits and using the D70 on a tripod without the ML-L3 remote control unit.
⟳ ▯	Delayed remote	Shutter released by the (optional) ML-L3 remote control unit. The D70 focuses (in AF mode) when the shutter-release button on the ML-L3 is pressed and shutter is released two seconds later.
▯	Quick-response remote	Shutter is activated by the (optional) ML-L3 remote control unit. The D70 will focus (In AF mode) when the shutter-release button on the ML-L3 is pressed and exposure occurs immediately after.

Long exp. NR (long exposure noise reduction)

Digital sensors are not affected by reciprocity law failure in the way film is. However, during long-time exposures (usually more than one second) digital sensors begin to generate noticeable noise. This takes the form of random, unrelated, bright pixels. It is particularly noticeable in dark areas, such as night skies. The noise displayed by the D70 is relatively low, and is evenly spaced, rarely leading to discoloured patches.

Other than under exceptional circumstances (such as for artistic effect), digital noise degrades image quality and should be minimized using the LONG EXP. NR function on the D70. When this function is on the camera will process images to reduce noise when the shutter speed exceeds one second.

To turn on long exp. NR A

1) Select **LONG EXP. NR** from the **SHOOTING** menu and choose the **ON** setting by pressing **ENTER** .

D70 buffer

The buffer is the temporary memory where images are stored immediately after exposure and while they are saved to the memory card. It allows picture taking to continue while the camera is processing just-recorded images. The D70 possesses a dynamic, rather than static, buffer. This allows the D70 to continuously record images while simultaneously writing them to the memory card.

The approximate number of images that can be held in the buffer at any one time is shown in the table below.

Image quality	Image size	Buffer capacity
RAW	N/A	4
JPEG Fine	Large	9
JPEG Fine	Medium	7
JPEG Fine	Small	19
JPEG Normal	Large	12
JPEG Normal	Medium	7
JPEG Normal	Small	27
JPEG Basic	Large	19
JPEG Basic	Medium	7
JPEG Basic	Small	49
RAW + JPEG Basic	Large	4

The number of images available in the buffer at any one time is shown in the exposure count display on the control panel and in the viewfinder when the shutter release button is depressed halfway.

Recording times

How quickly images are recorded to the memory card from the buffer depends on a number of factors including the type of memory card used, the file size of the image being recorded and the processing parameters set. Having spent a lot of money on the D70 don't hamper your photography by buying a cheap and slow memory card.

Notes

When images are being recorded to the memory card the access lamp will light up. Never remove the memory card or remove the power supply from the camera until the access lamp has gone out.

If you turn the camera off during recording, the power will continue until the buffer is empty and all images have been stored. However, in general, it is better to keep the camera power on until this process is complete.

Taking the picture

The D70 is a well-designed, lightweight camera, with a contoured body that makes handling simple. Despite its low weight the D70 feels very solid in the hand and all the main functions are easily accessible with the camera held in the shooting position. The lack of an optional vertical grip (with the additional functionality it provides) positions this camera very firmly in the consumer-grade market but that shouldn't deter anyone serious about their photography as the D70 boasts a number of features that surpass the more expensive, earlier D100 camera.

The D70's monitor is large enough to be practical but too small for serious in-the-field editing. The fonts used in the menu are quite large, which makes using the menu for function selection and camera set-up a simple enough task. A nice refinement in the D70 is the default automatic rotation of pictures taken in the vertical format when they are displayed on the monitor, see pages 101–2.

The viewfinder is bright and provides 95% coverage of the field of view. It's worth remembering this when composing images, as the final picture will show more than you originally saw through the viewfinder. Keep an eye open for any distractions that fall just outside the viewfinder frame as they may appear within the final image. The information available in the viewfinder when the camera is activated lacks for nothing and the option of turning on the on-demand grid lines (see page 114) is a feature I miss in the far more expensive, 'professional' D2H camera.

You can choose between five shooting modes: single frame, continuous shooting, self-timer, delayed remote shooting and quick-response remote shooting modes. In the continuous shooting mode the D70 can expose three frames per second and the dynamic buffer system enables the camera to keep shooting almost ad infinitum, although the frame rate may drop. With a fully charged battery Nikon claims the D70 is good for up to 2,000 images but this is achieved in laboratory conditions under ideal circumstances. In reality, particularly when using power-hungry functions such as Vibration Reduction and image playback, and when the temperature drops, expect to achieve a lower number of images per battery charge.

Focusing with the D70

The development of autofocus in camera technology was one of the great advances in photography. No longer having to rely on manual focusing, exponents of fast-action photography, including subjects such as motor sports and wildlife began to create images that, in technical terms, were far in advance of popular photography.

When used with AF Nikkor lenses autofocus activates when the focus mode selector is set to 'AF' and when the shutter-release button is depressed halfway. The D70 autofocus system operates across five separate detection sensors and with a choice of single area, dynamic area or closest subject priority modes selected via the custom menu, see page 111. Autofocus can be performed in either single servo or continuous servo modes, and predictive focus tracking automatically activates to keep moving subjects in focus.

For traditionalists, or when using manual focus lenses, and for those occasions when autofocus is more trouble than it's worth, the D70 can operate in manual focus mode. However, technology can still lend a hand, albeit with some exceptions, see page 184, and the D70 has an electronic rangefinder that activates small LEDs in the viewfinder indicating when the subject is in focus.

Focusing with Nikon

It is fair to say that, in the early days, Nikon was not the leader in the autofocus field, its technology lagging behind that of its main rival, Canon. Constant development over many years, however, has seen Nikon catching up and the autofocus system operational in the D70 is both fast and accurate.

⚠ Common errors

Some internet sites have reported slight focus calibration errors with early batches of D70s. It is unlikely that this will be a problem present on your camera or, even if it is, one that you will notice. However, shooting with an extremely wide aperture should highlight this if it is a problem at all. If this is the case contact your local Nikon dealer for support.

Focus mode

Focus can be switched between autofocus and manual focus by using the focus mode selector (**15**) located on the front of the camera to the left-hand side of the lens (facing away from you). Normally the D70 can be left switched to AF for autofocus, however sometimes it is necessary, or you may prefer to switch to M for manual focus, see page 80.

The autofocus mode that the D70 operates in depends on which exposure mode is in use. In the vari-program modes the D70 selects the most appropriate focus settings, see pages 85–7. However, if you use the D70 in **P**, **A**, **S** and **M** modes a number of focusing options become available. The shooting mode is examined in depth on page 69, and combined with the focus mode determines how the camera focuses and shoots.

In single-servo autofocus the D70 gives priority to correct focus and the shutter release will only activate once the focus is locked. Once correct focus has been detected focus remains locked so long as the shutter-release button is slightly depressed. In continuous-servo autofocus mode priority is given to shutter release and the shutter can be fired whether or not the subject is in focus. When autofocus is activated the lens focuses continuously until deactivated by fully depressing, or releasing pressure, on the shutter-release button. The focus mode can be changed in CS 02, see page 110.

Notes

For autofocus to operate successfully the lens in use must have a maximum aperture no smaller than f/5.6. While this covers the majority of the Nikkor lens range it excludes the use of a 1.4x teleconverter with lenses where the maximum aperture is slower than f/4, and with a 2x teleconverter with lenses where the maximum aperture is slower than f/2.8.

The electronic rangefinder only works with lenses with a maximum aperture of f/5.6 or wider.

Tip

Autofocus may fail to operate accurately when lenses are used in conjunction with linear polarizing filters. Use a circular polarizing filter instead.

Predictive focus tracking

When switched to AF the D70 utilizes its predictive focus tracking technology if a subject is moving. How it does this depends on which focus mode is selected. If the D70 detects that the subject is moving when AF is activated it will automatically begin predictive focus tracking.

When the D70 is in single-servo autofocus mode, if the subject is moving towards or away from the camera as the shutter-release button is semi-depressed, the D70 will track the subject's movement and adjust the focus accordingly. Focus will lock when the subject stops moving. The shutter-release button can then be fully depressed.

In continuous-servo autofocus predictive focus tracking will initiate whether the subject starts moving before or after the shutter-release button is semi-depressed. Focus will not lock and the shutter-release button can be released at any stage whether the subject is moving or not.

Single area, dynamic and closest subject priority focus modes

The D70 has a cross-shaped set of five focus areas that are displayed in the viewfinder. These areas can be selected either manually or automatically. However, before we look at selecting the focus areas manually we will examine the different autofocus area modes and the different shooting conditions that they are appropriate for.

Single area AF mode allows you to designate the focus area and your choice will remain unchanged even if the subject moves. This is particularly suitable for static subjects such as landscapes, still lifes and portraits. This is the default setting for the **P, A, S** and **M** modes and is also the setting for the vari-program close-up mode.

Dynamic area AF mode allows you to select a focus area and your choice of primary focus area will remain unchanged by the D70. Should the subject move outside the selected area the D70 will use the other focus areas to keep it in focus, however the selected focus area will not change. This is best used for keeping fast-moving and erratic subjects in focus.

Closest subject priority leaves the D70 to automatically select the focus area covering the subject closest to the camera. You cannot select the focus area manually and the focus area selected by the D70 will not be displayed on the control panel. However, it will be highlighted in the viewfinder when the D70 focuses. This is the default focus area setting for vari-program modes with the exception of the close-up mode. This mode allows for speed of operation and versatility, if you are just carrying your camera and don't know what photographic opportunities may be around the next corner I recommend using this mode. Closest subject priority is also ideal when there are distracting objects in the background that can lead to the autofocus system 'hunting'.

Tips

While the closest subject and dynamic area modes may seem similar, they do offer two fundamentally different options. Closest subject allows you to leave the camera to make the decisions and is best used when you're unsure of the photographic challenges you might face. Dynamic area offers the same core predictive tracking technology and is a better choice if you are able to spend a little time setting the shot up.

Tracking a subject that moves erratically requires skill, even with the aid of dynamic area AF. Try practising the technique with subjects such as a soccer match.

Notes

Once the primary focus area sensor is selected the active focus area indicator will not change even if the D70 subsequently shifts sensors.

In continuous-servo AF mode depressing the 'AE-L/AF-L' button (**27**) will lock focus.

Selecting AF area mode (B)

Once you have decided on the appropriate AF area mode you can select it via the custom settings menu (see page 111). This is not the most user-friendly means of switching between options and an on-camera switch would have been preferable.

1) In the CSM menu screen, choose CS 3. Use the multi selector to select either **SINGLE AREA, DYNAMIC AREA** or **CLOSEST SUBJECT**. Press **ENTER** to confirm your selection. See page 111 for more details.

Selecting the focus area (B)

As we've already seen in the section on focus area modes the Nikon D70 has a cross-shaped array of five focus area sensors. These are positioned at the top, bottom, left, right and centre of the frame. This enables you to select a focus area sensor that more closely matches the position of the subject, making autofocusing a far easier task, requiring less camera movement and reframing.

1) To select the required focus area, slide the focus selector lock (**7**) to the ● position and press the corresponding arrow (▲, ▼, ▶ or ◄) on the multi selector to move between the focus area brackets. Choose the focus area that is closest to the position of your main subject. The selected focus area bracket will be highlighted in bold or red in the viewfinder (unless CS 18 is set to OFF, see page 118) and will appear in the relevant position on the control panel and in the viewfinder display panel.

Note
Once you have selected a focus area you can lock it to prevent accidentally shifting focus areas by sliding the focus selector lock (**33**) to the **L** position.

Tip
The D70 offers a useful option in CS 17. You can set the D70's AF sensor selection to wrap around, see page 117. It's simply a matter of taste and what you are used to but I keep this function switched on all the time.

1) When correct focus is detected by the D70 the AF motors will stop and the lens will become still (if the subject is stationary). Focus status information is also provided via the electronic rangefinder: when the subject is in focus the in-focus indicator (a green dot) appears in the viewfinder.

AF-Lock

Once the D70 has indicated that it has achieved focus you can lock the focus in order to change composition. This allows you to transfer the point of focus to an area not covered by one of the five focus area sensors. In single-servo AF mode autofocus will lock automatically when focus is attained, by pressing the shutter-release button halfway or depressing the 'AE-L/AF-L' button (**27**). The image can then be recomposed.

With the D70 set to continuous-servo AF mode autofocus will not lock automatically. You must first depress the AE-L/AF-L button and then you can recompose your image. Once you are satisfied with the composition you can fully depress the shutter-release button and take a photograph.

In its default setting, locking the focus with the 'AE-L/AF-L' button will also lock the exposure at the same time.

Note
The functions of the 'AE-L/AF-L' button (**27**) can be varied in CS 15. See page 116.

⚠ **Common errors**
When using continuous-servo AF on subjects that fall outside the focus brackets remember to lock the focus before recomposing. Otherwise, autofocus will reactivate, rendering your subject out of focus.

AF-assist illuminator

When the D70 autofocuses in low-light it uses the AF-assist illuminator to increase subject contrast (**2**). However, it only works under certain conditions. First, CS 2 must be set to AF-S, see page110. An AF lens must be used, see page 184, and the central focus area sensor or closest subject AF mode must be selected, see pages 75–7. When these conditions are met the AF-assist illuminator will activate automatically if the subject is poorly lit, and the shutter-release button is semi-depressed.

For AF-assist to function properly the lens used must have a focal length in the range of 24–200mm and the subject must be within range (around 1ft 8in–9ft 10in (0.5–5m) for most lenses). Remove the lens hood if attached. The table, right, lists wholly and partially incompatible lenses.

Notes

AF-assist is not available in vari-programs ▨, ✦ and ▨.

When the D70 is operated with either the SB-600 or SB-800 external flash units the AF-assist illuminator on the camera will deactivate and the illuminator on the flash unit will turn on.

Ranges under 3ft 3in (1m)
AF Micro 200mm f/4D IF-ED
AF-S DX 12–24mm f/4G IF-ED
AF-S 17–35mm f/2.8 ED
AF 18–35mm f/3.5–4.5 ED
AF-S DX 18–70mm f/3.5–4.5G IF-ED
AF 20–35mm f/2.8
AF 24–85mm f/2.8–4 ED
AF 24–85mm f/3.5–4.5 ED
AF-S VR 24–120mm f/3.5–5.6 IF-ED
AF 24–120mm f/3.5–5.6
AF 28–200mm f/3.5–5.6G IF-ED
AF Micro ED 70–180mm f/4.5–5.6D ED

Ranges under 6ft 6in (2m)
AF-S DX 17–55mm f/2.8G IF-ED
AF-S 28–70mm f/2.8 ED

At all ranges
AF-S VR 70–200mm f/2.8G IF-ED
AF-S 80–200mm f/2.8 ED
AF 80–200mm f/2.8 ED
AF VR 80–400mm f/4.5–5.6D ED
AF-S VR 200–400mm f/4 ED

Manual focus

The D70 can be focused manually when necessary. For example, when in use with non-AF lenses or when the subject is defined less clearly.

To use the D70 in manual focus mode set the focus mode selector switch (**15**) to the 'M' position. You can determine correct focus in manual focus mode via the electronic rangefinder (with most Nikon lenses with a maximum aperture of f/5.6 or wider, see page 184) or via the focusing screen.

To use the electronic rangefinder **B**

1) Select one of the five focus areas (see page 77) and position it over the subject. Lightly press the shutter-release button and focus using the lens-focusing ring. When the subject is in focus a green dot appears.

Alternatively, simply look through the viewfinder and rotate the focusing ring until the image appears sharp.

Note
When using lenses with AF-M selection, select M when using manual focusing. If the lens supports M/A (autofocus with manual priority) manual focusing is possible with the lens set to M or M/A.

Prefocusing

Prefocusing is a useful trick to use in conjunction with autofocus. It is best used with dynamic autofocus mode and continuous-servo autofocus. If you are having autofocus problems, but don't want to rely on manual focus, try switching to MF mode, setting the focus close to the appropriate distance, and then switch the focus mode selector (**15**) back to AF. Then semi-depress the shutter-release button once the subject falls under the selected focus area.

Offering the D70 a nudge in the right direction can sometimes help autofocus to find its target, and I have found it particularly useful for fast-action photography where subjects will move predictably but quickly and are yet to appear.

⚠ Common errors
Never rotate the focusing ring on the lens with the camera and lens set to autofocus operation unless it has an autofocus with manual priority function, see page 176.

Tip
The D70 is marked with a focal plane indicator. The distance between the lens mount and the focal plane is 1.83in (46.5mm).

Depth-of-field preview

When a lens is attached to the D70 the camera automatically opens the lens aperture to its maximum setting. This is to ensure a bright screen on which to compose and focus the image. However, this makes it impossible for you to see the available depth of field when shooting at apertures narrower than the maximum. By stopping the lens down to the working aperture it is possible to see the exact depth of field through the viewfinder and take out much of the guess work involved in manual calculation.

To use depth-of-field preview first compose the picture and set the required exposure. Then, press the depth-of-field preview button (**7**). You'll hear a small click and the focusing screen will darken. By how much depends on the selected aperture – the smaller the aperture the darker the screen. If the selected aperture is the maximum lens aperture then no change in screen brightness will occur.

Tip
When working at small apertures the viewfinder will appear very dark and it takes some getting used to. Allow your eyes to adjust to the brightness level in order to assess depth of field.

Measuring depth of field B

1) To view depth of field at any given aperture, press the depth-of-field preview button (**7**) and look through the viewfinder to see which areas of the image space appear in focus. Those areas that appear sharp in the viewfinder will also appear sharp in the final image.

Notes

During depth-of-field preview the lens aperture cannot be adjusted and autofocus will not operate.

While the depth-of-field preview function can be activated in all exposure modes, it is best to use it in aperture-priority auto and manual exposure modes.

Depth-of-field preview funtion is not available with non-CPU lenses.

Correct exposure with the D70

While Nikon's autofocus system lagged behind that of its main rival for some time, its metering system was – and is still – second to none. The D70 combines data on scene brightness, contrast, colour and, when used in conjunction with Nikkor G-type or D-type lenses, distance-to-subject information in order to calculate correct exposure.

In many people's minds Nikon's automatic exposure system is near perfect. However, there are circumstances when it is best to apply manual control. For times like these, the D70 provides you with a flexible system capable of delivering accurate results in the most complex lighting situations.

The D70 has three metering systems, four main exposure modes and seven vari-program modes.

3D colour matrix metering

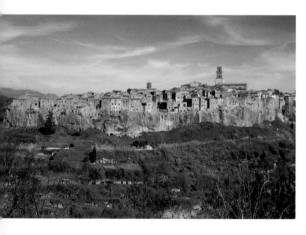

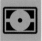 In calculating the correct exposure the system first measures the scene's overall brightness, contrast and colours on a special 1,005-pixel Red-Green-Blue (RGB) sensor. It then applies distance information, provided by Nikon G- or D-type lenses, and compositional information, provided by the auto-focus system. Although this system is not completely foolproof, it does provide accurate readings in most situations, whatever the complexity.

Notes

If lenses other than G- or D-type lenses are used then distance information is not calculated.

Matrix metering can only be used with lenses having a built-in CPU, e.g. AF Nikkor and AI-P lenses.

Centre-weighted metering

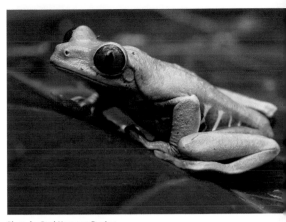

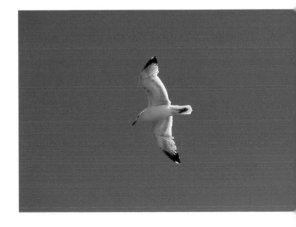

This is the classic form of autoexposure metering, and the one I use least. In default setting the D70 concentrates 75% of the meter's sensitivity in the 8mm-diameter circle seen through the viewfinder and 25% outside this area. This sensitivity can be altered via CS 11 and can be set to concentrate 75% sensitivity within a circle diameter of 6mm, 10mm or 13mm, see page 115. Typically, centre-weighted metering is used in portraiture or in other situations when the subject fills the centre of the frame.

Photo by Paul Harcourt Davies

Note
If you change the diameter of the centre-weighted reference circle, the size of the circle seen through the viewfinder remains unchanged.

Spot metering

Spot metering provides precise metering of a very small area of the picture space and gives you the greatest level of control over the exposure calculation. With the D70 the area of sensitivity is concentrated within a 2.3mm diameter area that corresponds directly to the selected focus area, covering approximately 1% of the picture space.

Selecting TTL metering mode Ⓑ

1) To select a metering system, simultaneously press the metering mode button (**37**) and rotate the main command dial until the corresponding symbol appears in the control panel.

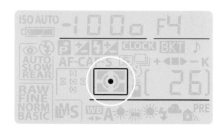

Choosing exposure mode Ⓑ

Which exposure mode you select will depend on how much control you want to maintain over lens aperture and shutter speed selection, and on whether lens aperture or shutter speed is more pertinent to your artistic interpretation of the subject. The D70 provides four traditional exposure modes and seven vari-program modes giving you complete flexibility in controlling exposure. To select your desired exposure mode, rotate the mode dial until the appropriate indicator aligns with the white mark:

Auto	Night portrait
Portrait	**P** Auto multi program
Landscape	**A** Aperture-priority auto
Close-up	**S** Shutter-priority auto
Sports	**M** Manual
Night landscape	

Note

When using a non-CPU lens, or accessories such as bellows or auto extension rings the metering system automatically switches to centre-weighted metering mode.

Vari-program mode

Using the vari-program mode, the D70 operates in fully automatic exposure mode and optimizes lens aperture and shutter speed combinations for specific subjects. This makes using the camera for 'point and shoot' photography a very simple process but is best avoided if you want a greater level of control over your image making.

Auto Auto

Exposure settings	The camera chooses the best combination of lens aperture/shutter speed depending on the subject and lighting
Focus area	Closest subject (default), dynamic area, single area
Flash sync	Auto front curtain (default), auto with red eye reduction, no flash
Use	General 'snapshot' photography

Portrait

Exposure settings	The camera chooses the best combination of lens aperture/shutter speed to soften and blur background details
Focus area	Closest subject (default), dynamic area, single area
Flash sync	Auto front curtain (default), auto with red eye reduction, no flash
Use	Outdoor portraits and indoor portraits under strong lighting
Tip	Use a short telephoto lens (70–100mm) for best results. If the subject is backlit or in shadow, use the built-in Speedlight to provide fill flash

Landscape

Exposure settings	The camera chooses the best combination of lens aperture/shutter speed for great depth of field, making objects sharp both in the foreground and background
Focus area	Closest subject (default), dynamic area, single area
Flash sync	Built-in Speedlight and AF-assist are disabled
Use	Landscape photography in good lighting
Tip	Use wideangle lenses (17–24mm) for best results and steady the camera on a tripod

🌷 Close-up

Exposure settings	The camera chooses the best combination of lens aperture/shutter speed to give vivid detail
Focus area	Single area (centre default), closest subject, dynamic area
Flash sync	Auto front curtain (default), auto with red eye reduction, no flash
Use	Photographing small objects such as flowers and insects
Tip	See chapter pages 162–71

🏃 Sports

Exposure settings	The camera chooses the best combination of lens aperture/shutter speed to freeze motion
Focus area	Closest subject (default), dynamic area, single area
Flash sync	Built-in Speedlight and AF-assist are disabled
Use	Photographing sports, pets, young children and fast-moving subjects
Tip	Focus mode switches to continuous-servo autofocus

🌃 Night landscape

Exposure settings	The camera chooses the best combination of lens aperture/shutter speed to allow long-time exposures
Focus area	Closest subject (default), dynamic area, single area
Flash sync	Built-in Speedlight and AF-assist are disabled
Use	Photographing outdoor scenes in low light and at night, such as a cityscape
Tip	Use a tripod and the self-timer or ML-L3 remote control to fire the shutter to avoid image blur caused by camera shake. Apply the noise reduction function in the menu options, see page 70

📷 Night portrait

Exposure settings	The camera chooses the best combination of lens aperture/shutter speed to allow an even balance between ambient background and artifical subject lighting
Focus area	Closest subject (default), dynamic area, single area
Flash sync	Auto slow curtain (default), auto slow with red eye reduction, no flash
Use	Photographing people in low light
Tip	Use a tripod and the ML-L3 remote control to fire the shutter to avoid image blur caused by camera shake. Apply the noise reduction function in the menu options, see page 70

Notes

Vari-program modes only operate with CPU-type lenses. When non-CPU lenses are used and any of the vari-program modes selected on the mode dial, the shutter is disabled.

The sRGB colour space is used for all vari-program settings. This makes them unsuitable for shooting images intended for further digital manipulation, see page 68.

Auto multi program mode (P)

In auto multi program mode the camera automatically selects both shutter speed and aperture. You can alter the combination, while maintaining consistent exposure, by using the Flexible Program function. For example, if the camera has selected an exposure of 1/125sec at f/8, you can use the Flexible Program function to shift the shutter speed/ aperture combination to, say, 1/250sec at f/5.6.

To select the Flexible Program function first make sure that you have selected P on the mode dial. Then rotate the main command dial, a P* icon will appear, to shift the aperture/shutter speed combination until your desired setting is shown.

Auto multi program mode is a simple way of controlling exposure. However, it places the onus of decision making on the camera and if, like me, you prefer to take control, then the following three modes will be more appropriate to your photography.

Aperture-priority auto mode (A)

In aperture-priority auto mode you select the aperture and the D70 sets the appropriate shutter speed depending on the meter reading. This gives you control over depth of field and is most useful where foreground to background sharpness is important, such as in landscape photography or in situations where selective focus is useful, such as macro photography. The range of apertures that can be selected depends on the lens that is in use.

Shutter-priority auto mode (S)

Shutter-priority auto mode allows you to select the required shutter speed (between 30 seconds and 1/8,000sec) while the D70 sets the appropriate aperture depending on the meter reading. This mode is often used by photographers of fast-action subjects, such as motor sports and wildlife, who use fast shutter speeds to freeze action or slow shutter speeds to blur motion, giving them creative control over the way that movement is depicted.

⚠ Common errors
There are a number of reports of colour shifts occurring when the D70 is used at it highest shutter speed of 1/8,000sec. In my opinion this is little more than scare-mongering. In reality it is unlikely that you will ever have to use as fast a shutter speed as 1/8,000sec and it appears that any colour shifts that do occur are only visible when saturation levels are turned right up.

Manual exposure mode (M)

For the ultimate exposure control the D70 can be operated in manual exposure mode, where you select both the aperture and the shutter speed. Most often this will be in conjunction with a meter reading from the camera but the manual system allows you to override any recommendations that the meter makes. Manual exposure is often used when the photographer wants to achieve special creative effects. The photographer has the capacity to set shutter speed between 30 seconds and 1/8,000sec, and manual mode also allows access to BULB mode, see page 95.

Taking meter readings in autoexposure modes Ⓑ

▣ 3D colour matrix metering

To take a meter reading in auto-exposure mode using the 3D colour matrix metering function, first compose the picture through the viewfinder. semi-depress the shutter-release button, the camera will then select the relevant shutter speed and lens aperture combination in vari-program and multi program auto mode; the shutter speed in aperture-priority auto mode; and the lens aperture in shutter-priority auto mode.

◉ Centre-weighted metering

To take a meter reading in auto-exposure mode using the centre-weighted metering function, first centre the main subject inside the viewfinder so it fills the reference circle, see page 83. Lightly press the shutter-release button, the camera will then select the relevant shutter speed and lens aperture combination in vari-program and auto multi program mode; the shutter speed in aperture-priority auto mode; and the lens aperture in shutter-priority auto mode.

⊡ Spot metering

To take a meter reading in auto-exposure mode using the spot metering function, first place the active focus bracket over the area of the scene you want to take the reading from. Lightly press the shutter release button to activate the meter. The camera will then select the relevant shutter speed and lens aperture combination in vari-program and auto multi program mode; the shutter speed in aperture-priority auto mode; and the lens aperture in shutter-priority auto mode.

Taking readings in manual exposure mode Ⓐ

In manual exposure mode the D70 provides an analogue display in the viewfinder as an aid to setting the correct exposure. Each marking along the top is permanent and represents a 1-stop change in exposure from +2 to –2. The markings along the bottom are non-permanent and represent a 1/3 or 1/2 change in exposure setting (depending on which option is selected in custom setting 9). When no markings appear along the bottom and a '0' appears above the centre index mark, then correct exposure is indicated. The number of markings appearing along the bottom indicates the level of under- or overexposure.

When the exposure setting is more than two stops under- or overexposed the bottom markers remain at the –2 or +2 positions, respectively. Altering the exposure settings will only cause the markers to change once they are within the +2 to –2 range.

1) To change the exposure, alter the lens aperture or shutter speed with the sub- or main command dials, respectively, until the correct exposure is indicated.

Tip
If the bottom marker keeps switching between two points it indicates that the level of light entering the lens is not constant. Bracket exposures, see page 93, to ensure an accurate image.

Exposing for off-centre subjects in centre-weighted metering mode and spot metering mode Ⓐ

1) In centre-weighted metering mode and spot metering mode, if the main subject falls wholly or partially outside of the focus area brackets, first position the subject in the viewfinder so it fills the reference circle or active focus bracket. Take your meter reading as described above.

2) If shooting in an autoexposure mode, lock the selected exposure settings using the 'AE-L/AF-L' button (**27**) or by keeping the shutter-release button semi-depressed. Recompose the scene, still keeping AE locked, and fire the shutter.

3) If shooting in manual exposure mode there is no need to lock the exposure settings. Once the correct exposure settings have been set recompose the scene as required and fire the shutter.

Selecting lens aperture and shutter speed settings (B)

Shutter speed is selected in shutter-priority auto and manual exposure modes by lightly pressing the shutter-release button and then turning the main command dial.

Lens aperture is selected in aperture-priority auto and manual exposure modes by slightly pressing the shutter-release button and then turning the sub-command dial.

Custom setting 14 can be used to switch the functions of the sub-command and main command dials. See page 116.

Notes

Auto multi program and shutter-priority auto exposure modes operate only with lenses that have a built-in CPU.

Adjustments of lens aperture (with CPU lenses) or shutter speed are made in 1/3 or 1/2 stops. This can be adjusted in CS 9, see page 114.

For use with lenses that have no CPU, or with accessories such as bellows or manual extension rings the D70 can be operated in manual exposure mode only.

Autoexposure lock (B)

1) Pressing the 'AE-L/AF-L' (**27**) button will lock the current exposure setting in all autoexposure modes. This is particularly useful when taking an exposure reading of a subject in spot metering mode, where the subject falls outside of the corresponding focus area sensor.

In this instance you would place the focus brackets on the subject to be metered. Once the meter reading had been taken and the appropriate exposure settings made, press the 'AE-L/AF-L' button and recompose the picture as desired. The exposure settings will remain locked until you release the 'AE-L/AF-L' button.

Notes

The lens aperture in aperture-priority auto, and the shutter speed in shutter-priority auto can still be changed even when the 'AE-L/AF-L' button is depressed. In this instance the shutter speed or aperture respectively will automatically shift to adjust to any changes you make.

The metering system cannot be changed when the 'AE-L/AF-L' button is depressed.

Exposure compensation

There are times when you need to make exposure adjustments, such as when photographing subjects that are considerably darker than, or lighter than midtone.

In any autoexposure mode this adjustment can be made by dialling in a level of exposure compensation between −5 to +5 stops in 1/3 or 1/2 steps, see page 114. In aperture-priority auto mode the D70 shifts the shutter speed by the required amount, while in shutter-priority auto mode it shifts the aperture. In auto multi program mode the camera shifts both aperture and shutter speed.

To set the level of compensation, simultaneously press the exposure compensation button (**40**) and turn the main command dial until the required amount is shown in the control panel and the viewfinder.

To reset compensation, press the exposure compensation button and simultaneously turn the main command dial until 0.0 appears. The ⚡ symbol will disappear from the control panel and viewfinder.

Tip
The level of exposure compensation remains fixed and the ⚡ symbol remains in the viewfinder LCD panel and on the control panel until it is reset.

⚠ Common errors

Because of the nature of CCDs, digital cameras are more prone to over- than underexposure. This is not a great problem with the D70 because of its excellent metering. However, you can use negative exposure compensation to prevent highlight detail being lost, then lighten the image using software. You can check highlight detail in playback mode, see page 108.

Complicated lighting has fooled the D70 into underexposing

+1 stop of exposure compensation has corrected the problem

Exposure bracketing

In some conditions it is impossible to calculate the correct exposure, or you may want to see the effects of different exposure settings. In this case you can bracket your exposures using the auto-bracketing function.

When you bracket exposure the camera takes a series of images at different exposure settings. For example, when photographing landscapes I will often take one image at the recommended meter reading, a second identical shot at 2/3 stop below the recommended meter reading and a third at 1/3 stop above the recommended meter reading. This gives me three almost identical compositions at three different exposure settings. Therefore, even if my original calculation was incorrect, one of the images will almost certainly have been accurately exposed.

To select the type of bracketing to be performed go to custom setting 12 in the menu and use the multi selector to highlight the appropriate setting:

AE⚡ Adjusts both exposure and flash level

AE Adjusts exposure only

⚡ Adjusts flash level only

To turn on auto-bracketing

1) Simultaneously press the **BKT** button on the rear of the camera and rotate the main command dial one click. The **BKT** symbol will blink on the control panel and in the viewfinder.

2) In auto-bracketing mode the D70 allows you to select the sequence and number of shots taken. To set the bracketing sequence, simultaneously press the **BKT** button and rotate the sub-command dial until the sequence that you require is displayed in the control panel.

+1 ±0 −1

Taking the pictures

When autoexposure bracketing is selected, and once you have determined and selected the number of frames to be taken and the sequence those frames are to be taken in, press the shutter-release button. In single frame advance mode bracketing is performed one frame at a time. In continuous shooting mode the shutter will fire the relevant number of frames so long as the shutter-release button remains depressed. Once the full sequence has been completed the shutter will deactivate until the shutter release button is released and pressed again.

A display in the control panel indicates the current status of the bracketing sequence and ⚡ flashes during a bracketing sequence.

Notes

In auto multi program mode the D70 alters both shutter speed and aperture when auto-bracketing. In shutter-priority auto mode the D70 adjusts the aperture only, and in aperture-priority auto mode the D70 adjusts the shutter speed only. Flash output is altered when using a dedicated flash.

If exposure compensation is set then bracketing will combine with the exposure compensation values.

If you fill the memory card in the middle of a bracketing sequence the D70 will continue with the sequence once a new memory card has been installed or images are deleted, even if the camera has been switched off.

To turn auto-bracketing off Ⓐ

1) Remember to switch off the autoexposure bracketing function once you have finished using it. To do this, press the **BKT** button and rotate the main command dial one click. The **BKT** symbol will disappear from the control panels. To cancel bracketing mid-sequence turn the auto-bracketing function off, as described above.

⚠ Common errors

It is easy when shooting moving subjects to forget at which point in a bracketing sequence you are at and you may end up completely out of kilter. To avoid this happening either switch off auto-bracketing or check regularly the sequence indicator display in the control panel.

Long-time exposure

For long-time exposures, beyond 30 seconds, the D70 has a bulb function, in which the shutter remains open so long as the shutter-release button is depressed.

1) To operate the D70 in bulb mode set the exposure mode to manual. Rotate the main command dial until the symbol **'bulb'** appears in the control panel and viewfinder.

⚠ Common errors

To avoid camera shake when operating the camera in bulb mode it is essential to mount the camera on a tripod.

It is also advisable to operate the shutter release via the ML-L3 remote control and cover the eyepiece with the eyepiece cap to prevent stray light from interfering with the 3D colour matrix metering system.

Tip

To reduce the level of noise created during long-time exposures, turn on the noise reduction function, see page 70.

Exposure warnings

In conditions that are too bright or too dark for the D70's exposure system to attain an accurate exposure the camera will display the following warnings:

HI Subject is too bright. Use an optional neutral density filter to reduce the level of light entering the lens.

LO Subject is too dark. Increase the sensitivity of the DPS (ISO-E) or use a flash unit to add more light.

Firing the shutter

The shutter-release button is on the top plate of the camera; there is no vertical shutter release button. Pressing it halfway will activate AF and AE functions. Fully depressing it will fire the shutter, and holding it down in continuous shooting mode will continue shooting while there is room in the memory cache.

Tip

When hand-holding the D70 fire the shutter while breathing out slowly for best results.

Self-timer mode

The D70 is equipped with a self-timer shutter-release option with variable duration. The self-timer can be used to reduce camera shake when the D70 is attached to a tripod or for self-portraits.

To use the self-timer Ⓑ

Ideally, mount the camera on a tripod, or use another form of support to ensure that the camera is secure.

1) Press the ▣ button and simultaneously rotate the main command dial until the self-timer icon ⟳ appears in the control panel.

2) Compose the picture and focus. If the subject is static I find it best to use manual focus, which gives the most accurate results. In single-servo AF mode, the camera must be in focus (indicated by ● in the viewfinder) before a picture can be taken.

3) To take the picture, press the shutter down fully. The self-timer will activate, the AF-assist lamp will blink and the beep will begin to sound (so long as ON is selected in CS 1). Approximately two seconds before the shutter is activated the AF-assist lamp will switch off and the beeping, if active, will become more rapid.

Once the picture has been taken the shooting mode will revert to the setting in operation prior to the self-timer being used.

4) To cancel the self-timer, switch off the camera or rotate the mode dial to another setting. The D70 will restore the shooting mode in use prior to the self-timer being used.

Tips

When using the self-timer, do not hold or touch the camera as this may cause camera shake.

Use the supplied eyepiece cap (DK-5) to stop stray light from entering the viewfinder and affecting the AE operation.

Notes

The length of delay in self-timer mode can be altered via CS 24. The default setting is ten seconds. See page 120.

If shutter speed is set to bulb then the approximate speed when used in self-timer mode is 1/5sec.

Using the self-timer with the built-in Speedlight (B)

1) To use the built-in Speedlight with the self-timer in **P**, **S**, **A** or **M** mode, raise the Speedlight by pressing the Speedlight lock-release button (**12**) and wait for the flash ready indicator to light in the viewfinder. Then press the shutter-release button.

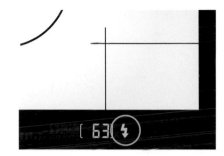

Using the ML-L3 remote control (A)

The D70 shutter can be activated using the optional ML-L3 remote control from a maximum distance of approximately 15ft (5m). Triggering the shutter remotely will reduce camera shake when the D70 is attached to a tripod and enables the shutter to be activated from a distance.

When using the ML-L3 remote control the D70 offers two shooting modes: delayed and quick response.

In delayed remote mode there is a delay between triggering the shutter and the shutter activating. This option is used mainly for self-portraits. In quick response remote mode the shutter is activated immediately or after focus is attained depending on CS 2 settings, see page 110.

1) To use the remote control, first attach the D70 to a tripod or place the camera on a solid, level surface. (Make sure the camera is secure before leaving it).

2) Press the ☐ button and simultaneously rotate the main command dial until ☼ (delayed remote) or ☐ (quick response remote) is displayed in the control panel.

3) Compose the picture and press the shutter-release button on the ML-L3. There must be a clear line of sight between the ML-L3 transmitter and the infrared receiver on the camera. The D70 will focus and trigger the shutter depending on the AF settings.

Using the remote control in AF mode

Delayed remote mode

AF-S The camera will focus and the shutter will fire after a two-second delay. If the camera us unable to attain focus then it will return to standby mode without releasing the shutter.

AF-C The camera does not focus and the shutter is released after a two-second delay.

Quick response remote mode

AF-S The shutter is triggered immediately after the camera attains focus. The AF-assist (self-timer) lamp will flash after exposure. If the camera is unable to attain focus then it will return to standby mode without releasing the shutter.

AF-C The shutter is triggered immediately without focusing. The AF-assist (self-timer) lamp will flash after exposure.

Notes

In manual focus mode, the D70 will not adjust the focus set by the user. Also, if focus has been set using the shutter release button on the camera, the focus setting is unaffected when the shutter is triggered by the remote control.

If no operations are performed within the timescale set in CS 25 (default is one minute), then the shooting mode in effect before remote control mode was set will be restored.

Remote control and long-time exposures A

1) By selecting '- -' in manual exposure mode the shutter can be triggered by the remote control and remains open until the shutter-release button on the ML-L3 is pressed again.

Tip

Make sure there is enough battery power to keep the D70 operational during exposures of long durations, and consider using the noise reduction function, see page 70.

Using remote control with the built-in Speedlight Ⓑ

When using the built-in Speedlight in remote control mode, the D70 will only respond to the ML-L3 when the flash is charged.

In 📷, 🌷, 🎭 and 🏔 modes, the flash will begin charging when either remote modes are selected. Once the flash has charged, the Speedlight will flip up automatically if required when the shutter release button on the ML-L3 is pressed.

If red-eye reduction, slow sync with red-eye reduction, auto with red-eye reduction or auto slow sync with red-eye reduction flash mode is selected, the AF-assist (self-timer) lamp will illuminate for one second before the shutter is triggered. In delayed remote mode, the AF-assist (self-timer) lamp will illuminate for around one second after the initial two second delay, during which time it will blink.

Tip

To prevent stray light from entering via the viewfinder and affecting the autoexposure operation, cover the viewfinder eyepiece with a dark-coloured cloth or with the DK-5 eyepiece cap before pressing the shutter release.

Notes

In **P**, **S**, **A** or **M** exposure modes, flipping up the built-in Speedlight during the two second countdown in delayed remote mode will cancel the timer. Wait for the flash to charge and press the shutter-release button on the remote control to restart the timer.

In AF mode, autofocus operation can be started by pressing the shutter-release button on the D70 halfway. However, only the shutter-release button on the ML-L3 will trigger the shutter when either 🕐 or 🏠 modes are selected.

Playback and viewing images

One of the main advantages of digital photography is the ability to instantly review your images on the camera's monitor. No more waiting until the film is processed to find out whether the exposure settings were correct, or that the lens aperture you set gave sufficient depth of field, or that the AF locked on to the main subject. You simply look in the monitor and, if you don't like what you see, throw it away and start again.

The PLAY menu

The PLAY menu is only available when a memory card is inserted and controls how images are displayed once a picture has been taken. It has six menu options:

Delete
Playback fldr (Playback folder)
Rotate tall
Slide show
Hide image
Print set

Using the delete menu Ⓑ

1) To delete one or more images individually, choose **SELECTED** in the menu options screen. The monitor will display all the photographs in the folder(s) selected in the **PLAYBACK FLDR** menu option as thumbnails.

2) Use the multi selector to navigate through the images and press **ENTER** to select a highlighted image for deletion. The image will be marked with a 🗑 icon. To add more images to the delete pile, repeat the process.

3) To deselect an image for deletion, highlight the image using the multi selector and press the centre of the multi selector (this can take a little

getting used to). Once you have selected each of the images to be deleted, press **ENTER**.

4) To confirm deletion, select **YES** and press **ENTER**. To exit without deleting any images select **NO** and press **ENTER**.

You can exit the **DELETE** menu without deleting images at any stage prior to confirming deletion by pressing the **MENU** button.

To delete all the images in a folder select **ALL** from the menu option screen. Select **YES** to confirm, and press **ENTER**. To exit without deleting images, select **NO** and press **ENTER**.

Notes

Images that have been protected using the ?/O⌐ button will not be deleted. To delete a protected image, unprotect it (see page 106) and follow the steps above.

Hidden images are not displayed on the monitor and therefore cannot be selected for deletion.

High-capacity memory cards with a large number of images stored on them may take several minutes to delete all images.

When deleting an image that has been recorded in RAW + JPEG format simultaneously both file formats will be deleted.

Playback folder Ⓐ

All images taken on the D70 are stored in a folder(s). Use the **PLAYBACK FLDR** menu option to display images within the current folder or all folders.

1) To display images in the current folder, select **CURRENT** from the menu options and press **ENTER**.

2) To display images from all folders, select **ALL** from the menu option and press **ENTER**.

Note

If the memory card is empty, or if any images on it were created with a device incompatible with the Design Rule for Camera File System (DCF)*, then the message FOLDER CONTAINS NO IMAGES will be displayed on the monitor.

*All Nikon digital cameras and most other makes of digital camera conform to the DCF rule.

Rotate tall Ⓢ

Images shot in the vertical (portrait) format can be automatically rotated so that they appear on the monitor in the format they were taken. To turn on automatic rotation, select **YES** in the menu option and press **ENTER**. When images are viewed they will be rotated and resized (to about 2/3 standard image viewing size) to fit the monitor space. If **NO** is selected, then images will be displayed in the horizontal (landscape) format.

Note

You must select **ON** from the **IMAGE ROTATION** menu option for automatic rotation on playback to work. Images that are taken when **IMAGE ROTATION** is **OFF** will be displayed in the horizontal format, irrespective of the selected setting in the **ROTATE TALL** menu option.

Slide show

Instead of playing back images individually, you can set the D70 to replay images in an automated sequence, much like a slide show.

1) From the **SLIDE SHOW** menu, select **START** to begin automated playback. To adjust the length of time an image is displayed, select **FRAME INTVL** and use the multi selector to choose an option (2 sec, 3 sec, 5 sec or 10 sec) and then press **ENTER**.

Slide show options	
Skip back or forward one frame	Use the ▲ (previous frame) and ▼ (next frame) arrows on the multi selector
View picture information	Use the ◀ and ▶ arrows on the multi selector to change the picture information displayed during playback
Pause	Press the **ENTER** button to pause playback
Exit (to PLAY menu)	Press the **MENU** button to exit the slide show and return to the PLAY menu
Exit (to PLAYBACK mode)	Press the **▶** button to exit the slide show and return to playback with current image displayed on the monitor
Exit (to shooting mode)	Press the shutter-release button halfway to exit the slide show and return to shooting mode

When the slide show ends, or is paused via the ENTER button, the last image in the file will be displayed on the monitor and the choice to restart or change the frame interval will appear at the bottom of the screen. To replay the slide show or to recommence playback, select **RESTART** and press ENTER. To exit the slide show press the MENU button.

Note

All images in the folder(s) selected in the PLAYBACK FLDR menu will be displayed in the slide show in the order they were taken unless they are hidden. Hidden images are not displayed.

Hide image A

Images taken on the D70 can be hidden from view. You can use this option when you want only certain images to be visible via playback or during a slide show. Hidden images can be unhidden by deselecting them.

1) To hide an image, select **HIDE IMAGE** in the **PLAY** menu and press ENTER. The images in the folder(s) selected in **PLAYBACK FLDR** will be displayed on the monitor.

2) Use the ◀ and ▶ arrows on the multi selector to highlight an image and press ▲ or ▼ to select it. The 🖾 icon will be marked on the selected image. Additional pictures can be selected by repeating this process.

3) To deselect an image, highlight it using the ◀ and ▶ arrows on the multi selector and press the centre of the multi selector.
 When you have selected all the images to be hidden, press ENTER.

Notes

When an image is hidden it can only be deleted by formatting the memory card.

To exit without changing the status of the selected images, press the MENU button.

Hidden images have a 'read only' status when viewed on a Windows-based computer. If you want to manipulate an image that was marked as hidden then save it with a different file name and reopen it.

If you have protected a hidden image using the ?/on button, unprotecting it will simultaneously reveal the picture.

Pictures taken on the D70 can be printed directly to a Digital Print Order Format (DPOF) printer. DPOF is an industry standard and it is important that you check whether your printer supports it before using this option.

1) To select image(s) and modify the print order, choose **SELECT/SET** from the **PRINT SET** menu option and use the ◄ and ► arrows of the multi selector to highlight an image.

2) Press the ▲ arrow on the multi selector to set an image for printing. The number of prints to be made will be set to 1. To change the number of prints to be made (up to a maximum of 99), use the ▲ and ▼ arrows on the multi selector. Pressing the ▼ arrow when the print number is set at 1 will deselect the image from the print set. The 🖫 icon and number of prints will be marked on the selected image. To add images to the print set, repeat the process.

3) To exit without changing the print order, press the **MENU** button.

4) To confirm the print order, press the **ENTER** button. The following sub-menu options will be displayed:

DONE (Completes print order modification and returns to the PLAY menu.)
DATA IMPRINT (Prints the shutter speed and aperture on all pictures in the print order.)
IMPRINT DATE (Prints the date the image was taken on all pictures in the print order.)

5) To choose any of the above menu selections, highlight the option using the ▲ and ▼ arrows on the multi-selector and press **ENTER**. A ✔ will appear next to the menu option to confirm selection. To deselect **DATA IMPRINT** or **IMPRINT DATE**, highlight the option and press **ENTER**.

6) To confirm your selections, highlight **DONE** and press **ENTER**. Press **MENU** to exit without changing the print order.

Notes

The PRINT SET option is only displayed when there is space on the memory card. To free up space delete some images.

Images taken for direct printing should be photographed in the Ia or IIIa (sRGB) colour modes (see page 68); or in the DIRECT PRINT mode (see page 204). The D70 is Exif (Exchangeable Image File Format) version 2.21 compliant, which optimizes colour reproduction when images are output to an Exif-compliant printer.

Single images In its default setting, the D70 displays the most recently taken image on the monitor while it is being recorded to the memory card, unless CS 7 is set to off, see page 113.

1) To display on the monitor images taken in the vertical format in the vertical orientation refer to page 101.

Images can be displayed on the monitor at any time by pressing the ▶ button. When the ▶ button is pressed then the most recently taken image or, if no new image has been taken since an image(s) has been reviewed, the last specified image is shown on the monitor.

Tip

By automatically displaying an image on the monitor while recording takes place the D70 uses a lot of battery power. I rarely find it necessary to review every image I take and prefer to select images for review manually. To turn off the automatic review option, select OFF in CS 7 and use the playback button to recall images to the monitor.

Viewing additional pictures

If more than one image is stored on the memory card you can scroll through all the images using the ▲ (view in reverse order) and ▼ (review in order taken) arrows on the multi selector.

Viewing photo information

Along with the actual image the D70 stores a large amount of shooting data. You can access this shooting data via the monitor using the ◀ and ▶ arrows on the multi selector. For more information on shooting data, see page 107.

Viewing images as thumbnails

Images can be viewed as small- or medium-sized thumbnails, rather than as single, screen-sized images. This helps when reviewing a number of images or when comparing one image with another.

To select the thumbnail playback option, press ▦. The display will switch between single-image playback, four- and nine-thumbnail images in the following rotation:

single-image
four-image thumbnail
nine-image thumbnail
single-image

Individual thumbnail images can be highlighted by using the multi selector.

Zooming in on a single image

1) Select an image in single-image playback or highlight an image in the thumbnail display and press **ENTER**.

2) To change the zoom ratio press and rotate the main command dial. then navigate the image using the multi selector.

Protecting an image (A)

1) To protect an image against accidental deletion, display the image in single-image playback or highlight an image in thumbnail mode and press the **?/On** button.
The image will be marked **On**.

2) To unprotect an image, display the image in single-image playback or highlight an image in thumbnail mode and press the **?/On** button.

Notes

Although protected images cannot be deleted using the 🗑 button or via the DELETE menu option, formatting a memory card will delete any images on that card.

If a protected image is downloaded to a Windows computer it will have a 'read only' status when viewed.

Deleting an image (B)

A displayed or highlighted image can be deleted by pressing 🗑 .

1) Press the 🗑 button and the message **DELETE?>YES** will be displayed on the monitor. To confirm deletion, press the 🗑 button again.

2) To exit the **DELETE** function without erasing an image, press any other button.

Notes

Hidden images will not be displayed during playback, either in single-image or thumbnail mode and therefore cannot be selected for deletion.

To delete multiple images, use the DELETE menu option in the PLAY menu and choose SELECTED.

Exiting playback Ⓑ

1) To exit the playback mode, press the ▶ button or press the shutter-release button halfway. Pressing the **MENU** button will return the display to the camera menus.

Note
The monitor will turn off automatically after a period of no operation. The length of time the monitor remains on can be set in the custom settings menu (CS 22).

Photo information Ⓐ

When the D70 records an image it also stores information about that image, which can be viewed during single-image playback (shooting data is not displayed in thumbnail mode).

1) To view the shooting data press the ◀ or ▶ arrows on the multi selector during single-image playback.

There are five information displays:

File information
Protect status
Frame number/total
 number of images
Folder name
File name
Image size
Image quality

Shooting data – page 1
Protect status
Frame number/total
 number of images
Camera name
Date of recording
Time of recording
Metering
Shutter speed
Aperture

Exposure mode
Exposure compensation
Focal length
Flash control

Shooting data – page 2
Protect status
Frame number/total
 number of images
Image optimization
Sensitivity (ISO
 equivalency)
White balance
White balance
 adjustment
Image size
Image quality
Sharpening
Tone compensation

Colour mode
Hue
Saturation

Histogram
Protect status
Frame number/total
 number of images
Histogram

Highlights
Protect status
Image highlights are
 marked by a flashing
 border
Frame number/total
 number of images

Histograms and exposure

The histogram is a visual representation showing the distribution of tones in the image. The horizontal axis corresponds to pixel brightness with dark tones to the left and bright tones to the right. The vertical axis shows the number of pixels of each brightness in the image. This information, although not a scientific measurement of exposure, can be used as a guide to indicate whether an image is under- or overexposed.

This image shows a histogram where the majority of the pixels are in the dark area, indicating possible underexposure.

Here most of the pixels are in the middle of the histogram, in the medium tone range, indicating that the exposure is accurate.

In this example, most of the pixels are in the bright area, indicating that the image is probably overexposed.

Highlights and exposure

The highlights display indicates those areas of the image that contain pixels that are pure white and will appear as washed out in the final image. If large areas of highlights are shown, consider adjusting the exposure to reduce brightness.

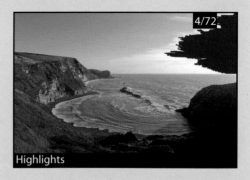

Customizing your D70

The D70 can be customized to suit your preferences and style of photography. Up to 25 different custom settings can be adjusted, from how camera functions such as autofocus operate, to how the camera handles and what the viewfinder displays. A number of these custom functions have already been covered earlier in this chapter, however they are all brought together here to provide one complete reference.

Choosing custom settings A

1) First you must choose whether you wish to see the full list of custom functions or the shortened version. I always leave it set to the detailed setting as I find the full list of custom functions easier to use. To select your choice go to the SET UP main menu, select the CSM menu then choose from **SIMPLE** or **DETAILED** and press the **ENTER** button.

2) In the simple CS menu you are given access to the first nine settings (as well as the reset menu function, see page 110). These options relate to the most frequently used features of the D70. In the detailed CS menu you have access to all 25 of the settings plus the reset menu function.

Note

When you scroll through the menu items the first and last item in the list are linked so that the menus rotate. For example, when **SIMPLE** is selected, pressing the ▼ arrow of the multi selector when CS 09 is highlighted will take you to R (Reset). Similarly, press the ▲ arrow when CS R is highlighted in the DETAILED CS menu to take you to CS 25.

Help in the field with custom settings B

1) When you're taking pictures with your D70 you can access help on the Custom Settings by pressing the **?/Oₙ** button on the camera back when a CS item is highlighted in the CSM menu or when options for a CS are displayed on the monitor.

A detailed guide to custom settings

CS Number	**R – Menu reset**
Option	No (default), Reset
Icons	None
Description	Resets ALL of the custom setting menu options to their factory default settings.

CS Number	**01 – Beep**
Options	On (default), Off
Icons	♪ in control panel when on; or ⊘ when off.
Description	The D70 beeps when the self-timer and delayed or quick response remote options are selected; or when the camera has focused in AF-S (single servo) mode. when switched **On**.
Field note	Turning the beep **Off** is advisable if photographing wildlife or at certain religious or cultural festivals.

CS Number	**02 – Autofocus**
Options	AF-S (standard default), AF-C
Icons	● in viewfinder when set to **AF-S** and subject is in focus. **AF-S** or **AF-C** appears in the control panel when AF is selected.
Description	In **AF-S** (single servo) mode the shutter can only be released once focus has been achieved. In **AF-C** (continuous servo) mode the D70 continues to focus so long as the shutter is depressed halfway. The shutter is enabled whether or not the camera is in focus.
Field note	The **AF-S** mode is most suitable for static subjects, such as portraits and landscapes. When your subject is moving, then **AF-C** is often the better option.
Notes	**AF-S** is the default setting except when the exposure mode dial is set to 🏃. The D70 automatically resets to **AF-C** when 🏃 mode is selected. When the exposure mode dial is set to any other vari-program mode the autofocus mode reverts to **AF-S**.

CS Number	**03 – AF-area mode**
Options	Single area (default), Dynamic area, Closest subject
Icons	⌐o⌐ single area; ⌐·⌐ dynamic area; ■ closest subject
	appears in the control panel and the viewfinder display.
Description	When the D70 is set to 'AF' focus mode, in **Single area** focus

When the D70 is set to 'AF' focus mode, in **Single area** focus mode the focus area target is set manually using the multi selector with the focus selector (**33**) unlocked. The D70 focuses on the subject within the selected target only. This option is best used when photographing static subjects, such as landscapes, still lifes and portraits.

When **Dynamic area** is selected the focus area target is set manually but the D70 will use other targets to determine focus if the subject moves during focusing, switching between target areas. (Note: the highlighted target area shown in the viewfinder and control panel remain unchanged even when the D70 shifts to a new target area.) This option is especially useful when photographing erratically moving subjects, such as birds in flight or children playing.

Selecting **Closest subject** focus area, the D70 automatically selects the focus area target containing the subject closest to the camera. The active focus area target is highlighted only when the camera has focused and the D70 will use information form other targets if the subject moves. When **AF-S** is selected in CS 2, focus will lock once the camera has focused.

Field notes

The **Closest subject** option combined with the **AF-S** setting in CS 2 helps to prevent out of focus pictures being taken when your subject is moving erratically within the picture space. Once set the focus can be locked using the focus selector lock (**33**).

Notes

Single-area focus mode is the default setting for **P**, **S**, **A**, **M** and 🌷 exposure modes. When 🌷 exposure mode is selected on the mode dial, CS 3 automatically sets to ⌐o⌐ **Single area** focus mode.

Closest subject is the default setting for 📷AUTO, 👤, 🏞, 🏃, 🖼 and 🔲 exposure modes and CS 3 automatically resets to **Closest subject** when 📷AUTO, 👤, 🏞, 🏃, 🖼 and 🔲 exposure modes are selected on the exposure mode dial.

CS Number	**04 – AF-Assist**
Options	On (standard default), Off
Icons	None
Description	When **On** the AF-Assist illuminator will light to aid focusing in low light conditions. To turn this function off select **Off**.
Note	The AF-Assist illuminator won't operate when ![icon], ![icon] or ![icon] exposure modes are selected.

CS Number	**05 – ISO Auto**
Options	Off (default), On
Icons	**ISO AUTO** is displayed in the viewfinder and on the control panel. The icon blinks to warn of auto-adjustments, unless a Speedlight is used.
Description	With the ISO Auto option **Off** the ISO-E remains at the manually selected setting, even if correct exposure is impossible.

Setting ISO Auto to **On** enables the D70 to alter the ISO-E set by the photographer when light levels are too bright or too dark for the manual setting to achieve an accurate exposure. Adjustments are made within the range of ISO-E 200 to 1600.

In the **On** mode you can confirm the current slowest available shutter speed setting for **P**, **A** and **DVP** exposure modes by highlighting **Done** and pressing **ENTER**.

To change the current shutter speed setting for **P**, **A** and vari-program exposure modes highlight **P**, **A**, **DVP MODE** in the menu and press the ▶ arrow on the multi selector. Use the ▲ and ▼ arrows to choose a shutter speed between 1/125sec and 30 seconds (in 1-stop steps) and press **ENTER** to confirm.

Note	The ISO-E value shown in the camera displays may vary from that used by the D70 when ISO AUTO is **On**.

With ISO Auto **On**, in **P**, **A** and all vari-program modes, the D70 automatically adjusts the ISO-E rating when the shutter speed needed for correct exposure is greater than 1/8,000sec or below the value specified for **P**, **A** and **DVP** modes. If correct exposure is still unobtainable at ISO-E 1600, the D70 will also adjust the shutter speed below the specified value.

In **S** mode the D70 adjusts ISO-E when the limits of the camera's exposure metering system are exceeded.

In **M** mode the D70 adjusts the ISO-E rating when correct exposure cannot be achieved at the selected shutter speed and lens aperture.

Tip If using flash, beware of bright daylight or brightly lit backgrounds causing overexposure of background subjects.

Field note Beware when ISO Auto is **On** that fast ISO-E settings will increase the level of digital noise apparent in the picture. Use the noise reduction function when ISO-E exceeds 400.

CS Number	**06 – No CF Card?**
Options	Release lock (default), Enable release
Icons	None
Description	In its default **Release lock** setting the D70 deactivates the shutter when no memory card is inserted in the camera. (Shutter release is not locked when the D70 is being operated from the optional Nikon Capture 4 v. 4.1 or later software package to record images directly to the computer.)

When set to **Enable release** the shutter can be activated whether or not a memory card is in place.

CS Number	**07 – Image Review**
Options	On (default), Off
Icons	None
Description	In its default **On** setting, the D70 will display newly taken photographs on the monitor automatically after exposure.

When set to **Off**, images are only displayed on the monitor after the ▶ button is pressed.

Field note Setting image review to **Off** will save on battery power during long spells in the field.

CS Number	**08 – Grid Display**
Options	On, Off (default)
Icons	Grid appears on the viewing screen
Description	The D70 viewfinder is supplied with an on-demand grid display. In the default setting this display is **Off**. To turn the display on select **On** in the CSM menu.
Field note	Grid displays are useful when composing landscape pictures or architectural images, in particular; or when using a tilt/shift lens.

CS Number	**09 – EV Step**
Options	1/3 step (default), 1/2 step
Icons	None
Description	Adjustments to both exposure settings and exposure/flash compensation settings can be made in either 1/3 or 1/2 exposure value increments.
	The default is **1/3 step** and selecting **1/2 step** in the CSM menu will cause the D70 to make adjustments in 1/2 EV steps.
Field note	For critical exposure calculations use 1/3 EV step adjustments.

CS Number	**10 – Exp Comp.**
Options	Off (default), On
Icons	None
Description	When set to **Off** (default), apply exposure compensation by pressing the 🔲 button and rotating the main command dial.
	This can be changed to using the command dials only for setting exposure compensation by selecting **On**.
Note	The dial used depends on the option selected in CS 14.
	CS 14 = **No**
	Mode **P** = sub-command dial
	Mode **S** = sub-command dial
	Mode **A** = main command dial

CS 14 = **Yes**
Mode **P** = sub-command dial
Mode **S** = main command dial
Mode **A** = sub-command dial

Selecting Exp Comp **On** has no effect when **M** or vari-program exposure modes are selected.

Field note Selecting **On** reduces the time taken to set exposure compensation. However, it does take a little practise to remember which command dial to use.

CS Number **11 – Centre wtd**
Option 6mm, 8mm (default), 10mm, 12mm
Icons None
Description The diameter of the circle used for centre-weighted metering where 75% of the weighting applies can be altered from its default setting of **8mm** to settings of **6mm**, **10mm** or **12mm**.

Note The size of the reference circle in the viewfinder remains the same whichever setting is selected in the CSM menu.

CS Number **12 – BKT Set**
Options AE & Flash (default), AE only, Flash only, WB bracketing
Icons None
Description When bracketing the D70 can be programmed to alter single settings or a combination of settings.
 In its default setting of **AE & flash** the D70 will apply bracketing by adjusting both AE (autoexposure) and flash level. When set to **AE only** the D70 will only adjust AE and flash output (if used) will be unaffected.
 To adjust flash output only, select **Flash only**.
 To bracket for WB and not exposure set the menu option to **WB bracketing**.

Note **WB bracketing** can only be selected for JPEG images.

CS Number	**13 – BKT Order**
Options	MTR>Under>Over (default), Under>MTR>Over
Icons	None
Description	Autoexposure bracketing can function in one of two sequences:

MTR>Under>Over

First picture taken at meter reading, second picture exposed under the meter reading, third picture exposed over the reading.

Under>MTR>Over

First picture exposed under the meter reading, second picture taken at meter reading, third picture exposed over the reading.

Field note	I don't recommend using bracketing when photographing moving subjects or image sequences.

CS Number	**14 – Command Dial**
Options	No (default), Yes
Icons	None
Description	In its default **No** setting the D70's main command dial adjusts shutter speed and the sub-command dial adjusts aperture. You can switch functions by selecting **Yes** in the CSM menu.
Field note	I usually employ aperture-priority auto mode, so I prefer to control aperture via the main command dial. This allows me to adjust aperture, with my finger on the shutter-release button.

CS Number	**15 – AE-L/AF-L**
Options	AE/AF Lock (default), AE Lock only, AF Lock only, AE Lock hold, AF-ON, FV Lock
Icons	None
Description	CS 15 controls the function of the AE-L/AF-L button (**27**) located on the back of the D70.

AE/AF Lock (default) = Locks both exposure and focus when pressed and held down

AE Lock only = Only locks exposure when kept depressed
AF Lock only = Only locks focus when pressed and held down
AE Lock hold = Only locks exposure when pressed. Exposure remains locked until pressed again or exposure meters turn off
AF-ON = Pressing the AE-L/AF-L button activates autofocus. In this instance, autofocus is no longer activated when the shutter release is pressed halfway
FV Lock = Flash level only locks when button is pressed, and remains locked until pressed again or exposure meters turn off

Field note I've never needed to use this button on any of my Nikon cameras. The best setting depends on your style of photography.

CS Number **16 – AE Lock**
Options AE-L button (default), + Release bttn
Icons None
Description In its default setting, **AE-L button**, autoexposure can only be locked by pressing the AE-L/AF-L button when AE/AF or AE lock only are selected in CS 15.
 The D70 can be set to lock exposure when the shutter release button is pressed halfway by selecting **+ Release bttn**.

CS Number **17 – Focus Area**
Options No wrap (default), Wrap
Icons None
Description In its default, **No wrap**, setting, the D70 is bound by the outer focus areas. For example, if the top focus area is selected, pressing the ▲ arrow on the multi selector will have no affect.
 Selecting Wrap allows the D70 to wrap around from top to bottom, bottom to top, right to left and left to right. Pressing the ▲ arrow on the multi selector with the top focus area selected will switch from the top focus area to the bottom one.

Field note Once familiar, this is a useful function that speeds up shooting.

CS Number	**18 – AF Area Illm**
Options	Auto (default), Off, On
Icons	None
Description	In it's default, **Auto**, mode the D70 will automatically assess the brightness of the scene being photographed and highlight the selected focus area whenever necessary.
	To turn off highlighting of the selected focus area select **Off** in the CSM menu. To always highlight the selected focus area irrespective of the scene brightness, select **On**.

CS Number	**19 – Flash Mode**
Options	TTL (default), Manual, Commander Mode
Icons	⚡± blinks in control panel and viewfinder when manual flash mode is selected.
Description	The built-in Speedlight can be operated in three different flash modes.
	In the default **TTL** setting, the D70 automatically adjusts the flash output for the prevailing shooting conditions.
	When set to manual mode, flash output can be adjusted between full power and 1/16 power when operated at AE settings **P**, **S**, **A** or **M**.
Notes	At full power the guide number of the built-in Speedlight is 56ft/17m at ISO-E 200 or 39ft/12m at ISO-E 100.
	No monitor pre-flash is emitted, allowing the built-in flash to function as the master unit for optional slave flashes.
	In **Commander** mode the D70 can control the flash level when one or more SB-800 or SB-600 Speedlights are used for wireless flash photography in exposure modes **P**, **S**, **A** and **M**.
	From the CSM menu, select **TTL** (only available when using CPU lenses), **AA** (only available with CPU lenses and SB-800 Speedlight) or **M** (manual).
	In **Manual** you can select the power output of the flash from full power to 1/16 power.
	The ⚡ will not be displayed in flash sync mode icon when built-in Speedlight is raised in **Commander** mode.

CS Number	**20 – Flash Sign**
Options	On (default), Off
Icons	⚡ in viewfinder
Description	When set to **P**, **S**, **A** or **M** modes the built-in Speedlight must be activated manually.
	In its default setting, **On**, the D70 indicates by illuminating and flickering the flash sign when flash should be used.
Notes	The flash sign disappears when the built-in Speedlight is raised or an external flash unit is attached to the camera.
	To turn off the flash sign completely, select **Off** in the CSM menu.

CS Number	**21 – Shutter Spd**
Options	1/60 (default), 1/30, 1/15, 1/8, 1/4
Icons	None
Description	Use this option to determine the slowest shutter speed available when using flash in **P** or **A** mode.
	Slowest shutter speed can be set between 1/60sec (default) and 30 seconds.
Note	When flash sync mode is set to slow sync, see page 147, shutter speeds as slow as 30 seconds are always available.

CS Number	**22 – Monitor Off**
Options	10s, 20s (default), 1min, 5min, 10min
Icons	None
Description	How long the monitor remains on when no operations are performed can be adjusted from 10 seconds to 10 minutes.
Note	When the D70 is used in conjunction with the EH-5 AC Adaptor the monitor will remain on for 10 minutes regardless of the selected CS option.
Field note	The longer the monitor is on the more battery power it uses. Only leave the monitor on for as long as is necessary.

CS Number	**23 – Meter-off**
Options	4s, 6s (default), 8s, 16s, 30min
Icons	None
Description	How long the meter displays remain when no operations are performed can be adjusted from four seconds to 30 minutes.
Note	When the D70 is used in conjunction with the EH-5 AC Adaptor the meter displays will remain on regardless of the selected CS option.
Field note	The longer the meter displays are active the more battery power is used. Only leave the meter displays on for as long as is necessary.

CS Number	**24 – Self-timer**
Options	2s, 5s, 10s (default), 20s
Icons	None
Description	The length of delay when the self-timer is used can be adjusted between two and 20 seconds.
Field note	When using the self-timer to activate the shutter when the camera is on a tripod and no remote is being used, select a short time delay of around two seconds.

CS Number	**25 – Remote**
Options	1min (default), 5min, 10min, 15min
Icons	None
Description	When the D70 is set to remote shooting mode (either delayed or quick response) the camera will turn off and revert to either single-shot or continuous shooting if no operation is performed within one minute, see page 69.
	This can be extended by choosing a custom option of either five minutes, 10 minutes or 15 minutes.

Resetting the D70

You can restore the default settings of the D70 by pressing the [BKT] and [⊞] buttons (marked with a green dot) simultaneously and holding them for around two seconds. Custom settings will remain unchanged but the following will be restored to their default settings:

CAMERA SETTINGS	
Option	**Default setting**
Shooting mode	Single frame*
Focus area	Centre^
Metering	Matrix
Flexible program	Off
AE lock	Off
Exposure compensation	±0
Bracketing	Off

FLASH SYNC MODE	
Option	**Default setting**
P, S, A and **M**	Front curtain sync
[AUTO] 🏃 🌷	Auto front curtain sync
[⊡*]	Auto slow sync
Flash compensation	Off
FV lock	Off±
LCD illuminator	Off

SHOOTING MENU	
Option	**Default setting**
Image quality	JPEG Normal
Image size	Large
White balance	Auto (Fine tuning reset to 0)
ISO-E	200
Optimize image	Normal

* Shooting mode is not reset in self-timer and remote modes
^ Focus area is not reset when CLOSEST SUBJECT is selected from custom setting 3 (AF-area mode)
± Custom setting 15 (AE-L/AF-L) is unaffected

To reset the Custom Settings menu select **RESET** for Custom Setting R (RESET MENU).

To completely reset all of the D70's functions press the reset switch ([10])

Into the field

So, that's the theory out of the way. But how does the D70 perform in the field and how do you get it to do what you want it to, when you want it to – all of the time?

As we've seen from the previous chapter, the D70 has more than enough technological wizardry to deliver in the most trying conditions. But all that technology is wasted if, when it matters, you're scrambling around in your rucksack for the manual – or this technical guide!

The purpose of this chapter is to take the theory covered in chapter 2 and relate it to my in-the-field experience. Of course, it will be impossible to cover every

eventuality, but hopefully the examples will give you some practical pointers.

Whenever I buy a new camera the first thing I do is familiarize myself with it. I practice working with the camera while enjoying a beer in my armchair. My wife thinks I'm nuts but, there have been many occasions when all that practice has paid off in the field.

Murphy's law says that the killer image normally appears when your camera is safely tucked up in its backpack. When I'm working, my camera is always to hand, switched on and fitted with the most appropriate lens, and if necessary speedlight, for the situation. This way, if a photo opportunity were to appear unexpectedly, nine times out of ten I'm ready for it.

Think about your shoot before you start out. Consider the subjects you will encounter, the conditions and most importantly how your D70 will need to operate. You can also set any custom functions that you think will be useful.

One of the more tedious aspects of digital photography is managing your files. I find that it helps me to keep a lot more organized if I create a folder for each day's shoot with the date as the folder name, see page 39. I also reset the file number sequence (see page 41)

Pre-shoot checklist

✔ Batteries charged

✔ Memory card empty and inserted

✔ Folder created and named

✔ File No. Seq. reset

✔ Select comment to be attached to all photos

✔ Record new Dust Ref Photo

before I start, meaning that the first image of the day will be numbered 0001 and any subsequent images created, even in new folders, will continue in sequence.

All of this is time consuming. However, it is the lesser of two evils, disorganized files, a full memory card or flat batteries can all cause a lot of frustration, and a little time spent organizing before the shoot will save you a lot of time during and after it.

When I'm working in the field I follow a few additional rules. As well as a couple of spare memory cards, I also carry a spare battery.

One of the biggest challenges in wildlife photography is anticipating the shot, and it's a lot easier to do when all I'm thinking about is the animal rather than my camera.

SUGGESTED SETTINGS

Below are the my normal settings for the D70. They won't suit everyone's style of photography, but they should give you an idea of what to think about.

Function	Setting	Reason
Image quality	NEF RAW	Maximum quality and ease of post-camera manipulation
ISO-E	200	Maximum quality for good light conditions
White balance	Cloudy	Gives images a 'warm' tone
Optimizing images	Default	Allows me to set individual parameters
Sharpening	Medium high	Avoids problems caused by over-sharpening
Tone Comp	Normal	Allows me to use curve tools later
Colour mode	Adobe RGB	Most appropriate setting for manipulation and publication
Saturation	Normal	Vibrant but realistic colours
Hue	0•	Hue is easier to adjust, if necessary, on computer
Shooting mode	Continuous	Fast frame rates are vital for wildlife shots
Focus mode	AF	The D70 is highly accurate in most situations

CUSTOM SETTINGS

Beyond its standard settings the D70 offers 25 custom functions. Again, here are the settings that I use most often and the reasons for my choices.

No.	Custom Function	Setting	Reason
01	Beep	Off	Less obtrusive
02	Autofocus	AF-C	For fast-moving subjects
03	AF-area mode	Dynamic area	For fast autofocus response
04	AF assist	AF-Assist off	AF-Assist illuminator can attract unwanted attention when photographing wildlife
05	ISO auto	Off (default)	Sensitivity remains as selected
06	No CF card?	Release lock	
07	Image review	Off	Saves on battery power
08	Grid display	On	Helpful compositional tool
09	EV step	1/3 step (default)	More exposure control
10	Exp comp	Off (default)	I like the security of pressing ±🗲
11	Centre wtd	8mm (default)	I use this metering mode the least so leave it in its default setting
12	BKT set	AE only	I prefer controlling flash directly
13	BKT order	MTR>under>over (default)	
14	Command dial	Yes	I like to use the main command dial for aperture control in A mode
15	AE-L/AF-L	AE/AF Lock (default)	I tend not to use this function so leave it in default mode
16	AE Lock	AE-L button (default)	I tend not to use this function so leave it in default mode
17	Focus area	Wrap	For extra speed of use

18	AF area illm	Auto (default)	Allows the D70 to select the level of illumination
19	Flash mode	TTL (default)	Nikon's i-TTL system is fast and accurate
20	Flash sign	On (default)	A useful reminder
21	Shutter spd	1/15	Gives more flash exposure options
22	Monitor off	10s	Shortest time for longest battery life
23	Meter-off	6s (default)	Long enough to make exposure decisions without excessive battery consumption
24	Self-timer	2s	For quick response
25	Remote	15min	So I don't have to keep resetting it

A D70 in the hand

As well as being switched on, the camera is also set to its most functional settings for my style of photography. The exposure mode is set to aperture-priority auto mode for both landscape photography and when I'm shooting wildlife. The metering mode is set to the highly reliable 3D colour matrix metering system and autofocus is set to continuous-servo and shooting mode is set to continuous.

Because much of my work in wildlife photography requires quick reactions and leaves little time for planning I usually leave many of the image processing functions accessible via the menus in a standard setting and worry about adjusting them later on computer.

I also switch off the image review function as I like to decide which images I want to investigate on the monitor. I find that this saves battery life quite considerably, which gives me more shooting time in the field.

The other eventuality I plan for is a tripod. I currently use a Velbon carbon fibre tripod with a Manfrotto quick release pan and tilt head for most of my work, except when using super-telephoto lenses when I switch to a sturdier Gitzo tripod with a special head. A quick release plate is always attached to the base

of the D70 so that setting up the camera on the tripod becomes a quick and simple task.

You will note that everything I've talked about so far is based around speed of operation. That's because in wildlife photography speed can be the difference between success and failure. Of course, depending on your particular photographic interests and personal style, speed may not be the be all and end all. But one of the D70's greatest selling points is exactly that and some of the above disciplines are discussed in order to help you handle the D70 in the manner for which it was built.

> **Tip**
> While the D70 has a very fast power-up time it is quicker still to keep it switched on. The monitor-off function will kick in, to preserve battery power, and the camera can effectively be switched on by touching the shutter button.
> This technique is heavy on batteries so only use it when you must.

Exposure and focus

Besides composition and use of light, the two most important elements of a compelling photograph are correct exposure and accurate focus.

Defining what the words 'correct' and 'accurate' really mean when applied to exposure and focus is a complicated affair and not a topic for this book. Instead, the next part of this chapter will look at getting the most out of two of the D70's most advanced features: TTL exposure control and autofocus.

TTL exposure control
The D70 has three different TTL metering systems: 3D colour matrix, centre-weighted and spot. The area of the scene that influences the camera's calculations vary depending on the system you are using and will affect the way the final image is recorded on the CCD. The decision you have to make is, which area of that scene is most important to the photographic message you're trying to communicate and which of the three available systems best suit the prevailing conditions relative to your subject.

Right: This illustration indicates which area of the viewfinder the D70 takes light level data from and in what proportions, depending on the metering system selected.

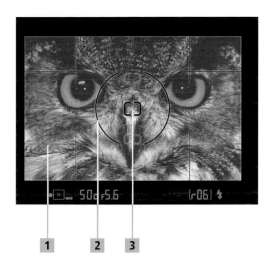

1 3D colour matrix metering (⬚) utilizes information from the whole scene, in conjunction with subject position and colour

2 Centre-weighted metering (⬚) takes readings from the whole scene but weights exposure for the central 8mm reference circle (adjustable in custom function 11)

3 Spot metering (⬚) takes light readings from a 2.3mm circle centred on the current focus area, or the central focus area

Understanding how the D70 gathers light level data will make selecting the right metering system for any given lighting conditions that much easier, and your exposures will become more consistent and accurate.

The D70 also provides four traditional exposure modes: auto multi program, aperture-priority auto, shutter-priority auto and manual, as well as seven vari-program automatic settings. Each of these modes gives you varying degrees of control over the exposure settings. Which of the modes you should use in any given set of circumstances will depend on how you want the final image to appear, and understanding the relative effects of each on the way a scene is recorded will go a long way to ensuring that the final image lives up to your photographic expectations.

If you are going to get the most from your D70 you will have to take control over exposure. Because auto multi program and vari-program modes allow you very little control over the exposure settings I have concentrated on those modes that do: aperture-priority auto, shutter-priority auto and manual.

Aperture-priority auto mode (A)

This is the mode I have set most often. Aperture-priority auto mode gives you control over the lens aperture while the camera sets an appropriate shutter speed, depending on the meter reading and any exposure compensation you've dialled in. Taking control over the lens aperture means you have control over the depth of field. For front to back sharpness – large depth of field – you need to select a small aperture, e.g. f/16, f/22 or f/32. For shallow depth of field, for example where you want to purposefully blur the background, then you need to set a large aperture, e.g. f/2.8, f/4 or f/5.6. Of course, these are just examples and the exact settings you use for any single image will depend on the specific equipment used and the conditions prevalent at the time.

Note
Aperture also has an impact on the quality of the image. See page 169 for more on optimum aperture.

Hyperfocal distance

When autofocusing on distant objects the D70 will focus on infinity. While this is acceptable in most situations you can squeeze even more depth of field out of your lens by using hyperfocal focusing. To focus hyperfocally follow these four steps:

1) Switch the D70 to manual focus mode and focus on infinity.
2) Set the lens to its narrowest aperture.
3) Depress the depth-of-field preview button and note the point closest to the camera that is still in acceptably sharp focus – this is the hyperfocal point.
4) Refocus the lens to the distance of the hyperfocal point and depress the shutter-release button.

This process will give you depth of field that stretches from slightly in front of the hyperfocal point all the way back to infinity.

Shutter-priority auto mode (S)

In shutter-priority auto mode you control the shutter speed while the D70 sets an appropriate aperture to give an accurate exposure setting, taking into account any manual adjustments you've made. Controlling the shutter speed means you have control over the way motion is depicted in the final image. To freeze subject action or motion, such as a running bear or a waterfall, then a fast shutter speed is needed. The exact shutter speed needed to freeze action depends on a number of variables including the speed and direction of the subject.

At the opposite end of the spectrum, a slow shutter speed, will blur subject action giving the appearance of motion in a scene.

Extremely long shutter speeds can be used to render motion as streaks, for example light trails from traffic. They can also be used in extreme low light conditions such as night photography. In shutter-priority auto mode shutter speeds of up to 30 seconds can be set. For shutter speeds longer than 30 seconds you can switch the D70 to manual and select bulb mode, see page 95.

⚠ Common errors

If you select bulb in manual mode and then switch the exposure mode to shutter-speed priority, the shutter will lock. Change the shutter speed by rotating the main command dial.

Tip

Exposures over one second will suffer from noise. To minimize this select the long exposure noise reduction function, see page 70.

Manual exposure mode (M)

With the D70 set to manual exposure mode you take complete control over exposure settings, while the D70 indicates an exposure reading via its TTL meter. Typically, I use manual mode when making a number of adjustments to the exposure because of very complex lighting conditions, or

when using certain types of filter, such as neutral density (ND) graduated filters. Using manual exposure mode also means I never have to use the AE lock function, since once I've dialled in the lens aperture and shutter speed settings, they will remain in place until I change them.

In this scene I felt the levels of contrast were too high for the D70's 3D colour matrix metering system to give me an accurate reading. Between the brightest parts of the scene (the surf) and the shadow on the rock arch there was a variance of around $6\frac{1}{2}$ stops.

I switched to spot metering mode and took three different readings. The first reading was taken from the bright area of surf in the bottom of the picture. The second reading was taken from the blue sky (a middle tone) and the third reading was taken from the area of rock jutting out into the sea. I also switched the exposure mode to manual as I was going to make some adjustments.

I used the meter reading from the middle tone sky as my base setting and added a two-stop neutral-density graduated filter in the inverted position over the clouds, to even the contrast of the scene.

JURASSIC COAST
Dorset, UK

D70 settings:
Metering system – spot
Exposure mode – manual

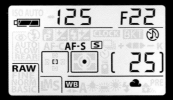

Even-tone conditions

Photographing portraits in even-tone conditions is ideal for the D70's centre-weighted metering system working in aperture-priority auto mode. The aim with this composition was to soften the background so that it didn't detract from the main subject and to render the background darker than it actually was, in order to help the model stand out.

I switched to centre-weighted metering – a rarity for me – and aperture-priority auto mode. I used a wide aperture to soften the background, while keeping the model's eyes sharp. The model's head and neck pretty much filled the 8mm-diameter reference circle, giving me a base reading for the lighting conditions. I then applied +1 stop exposure compensation (human skin is roughly one stop brighter than midtone), which gave me an accurate exposure.

This image is a great example of working in centre-weighted metering mode, where the main subject fills the central portion of the image space, and illustrates how aperture-priority auto mode allows you to control the depth of field within a scene.

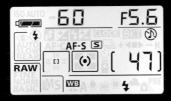

D70 settings:
Metering system – centre-weighted
Exposure mode – aperture-priority

POSED MODEL

Complex lighting conditions

I had determined that although the tonal range of this scene was extensive, the level of contrast was ideal for the image I wanted to create – a silhouette. I switched the D70 to 3D colour matrix metering mode, confident that it would give an exposure that would underexpose the grasses. In this case, I wanted to maintain control over depth of field and so I elected to use aperture-priority auto mode.

I set the aperture to f/11, a setting I knew from experience would render the foreground grasses sharp, while softening those in the background.

GRASSES AT SUNSET

D70 settings:
Metering system – 3D colour matrix
Exposure mode – aperture-priority

Using autofocus

The D70 comes with three different AF area modes – single area, dynamic and closest subject. In single area mode the focus is set to one of the five focus area sensors and if the subject moves out of that sensor's range then you will need to refocus. For this reason, single area focus mode is best suited to static subjects, such as portraits, still life or landscapes, or for use when panning the camera with a moving subject where the focus distance remains constant, such as following the line of a racing car. In dynamic area focus mode focus is fluid. The D70 detects the movement of the main subject and shifts between focus sensors to track its movement around the picture space. For this reason, dynamic area focus mode is designed for photographing moving subjects, such as in wildlife and sports photography. In closest subject AF mode the D70 detects the subject closest to the camera position and automatically selects the appropriate focus sensor. This setting is ideal when there are distracting objects in the background that can lead to autofocus 'hunting', or when a subject is moving erratically.

You can also select one of two focus servo modes: single servo or continuous servo. In single-servo mode, once focus has been locked it will not change even if the subject moves. In continuous-servo mode the D70 will continue to track the movement of the subject as it changes position in the viewfinder and adjusts focus accordingly. Single servo mode, then, is best suited to conditions where the camera-to-subject distance is constant, whereas continuous servo mode works more effectively with subjects where the camera-to-subject distance is variable.

Putting everything into practice

So how does all that work in the field? In the same way I demonstrated the use of exposure modes and systems in the previous section, I have used the images on the following pages to illustrate the use of the D70's autofocus system in a real environment.

In this scene I was standing in the river watching the bear head straight for me. The camera was already set to dynamic area focus mode in continuous-servo mode – as it always is when I'm photographing wildlife – so I switched the principle focus area sensor to the top sensor. Next I determined the point at which I'd fire the shutter, ahead of the bear, and waited for it to move into the picture space. As soon as the position of the bear corresponded with the upper most sensor I activated autofocus by semi-depressing the shutter-release button. The D70 then tracked the bear's movement down through the central sensor and I fired the shutter.

In this image focus remains sharp even though camera-to-subject distance is constantly changing because the D70 is able to react quickly to subject movement through dynamic area and continuous-servo modes.

BROWN BEAR
Katmai National Park, Alaska, USA

D70 settings:
Focus area mode –
dynamic AF
Focus mode –
continuous servo

LIONESS
Limpopo Region,
South Africa

I used a similar technique with this subject, except that the movement of the lioness was from right to left rather than top to bottom. With this image I again determined the point at which I'd fire the shutter and then set the principle focus area sensor to the right sensor in the viewfinder. As the lioness entered the frame I activated autofocus and allowed the D70 to track its movement towards the centre of the image space. At that point I fired the shutter and captured the image. This picture again demonstrates the effectiveness and accuracy of the dynamic AF function when used in continuous-servo mode, this time with a subject moving across the frame.

D70 settings:
Focus area mode –
dynamic AF
Focus mode –
continuous servo

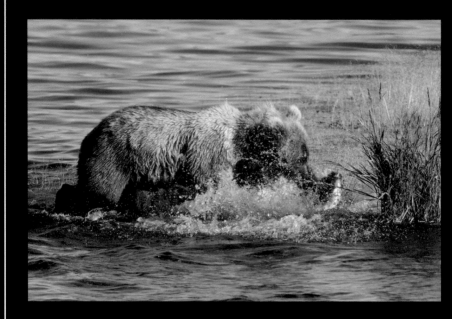

BROWN BEAR
Katmai National Park, Alaska, USA

D70 settings:
Focus area mode – single area
Focus mode – continuous servo

I had been watching this yearling chase salmon for most of the morning and trying to keep up with his antics was a real challenge. As the bear entered this area of open water it was running parallel to my position rendering camera-to-subject distance constant. I switched the D70 to single area mode, while keeping it in continuous servo mode and, after locking focus on the bear's eye, panned the camera to follow its movement. At the right moment I then fired the shutter. Single area focus mode was suitable on this occasion because, although the subject was moving, the camera-to-subject distance remained the same.

Subject off-centre

This close to an ostrich and you don't want to hang around too long – they may look harmless enough but they have one almighty kick for any photographer that gets too close. The challenge with this shot was keeping the eye of the ostrich in focus. I switched the D70 to single area, single-servo modes and, with the active focus area set to the centre sensor, I activated autofocus. Holding the shutter-release button semi-depressed I then recomposed the picture to give this composition before firing the shutter and making a quick exit. What this image demonstrates is the flexibility of the D70's autofocus system in dealing with all kinds of photographic challenges.

D70 settings:
Focus area mode – single area
Focus mode – single servo.

OSTRICH
Kruger National Park, South Africa

Chapter **4**

Flash and the D70

Flash photography is one of those disciplines that can cause endless frustration to photographers. The problem is that the laws of physics govern flash exposure, and physics is a subject many photographers – including this one – are all too unfamiliar with.

The D70 simplifies flash use and removes the physics from much of the equation. The built-in Speedlight is handy for simple everyday use. However, you can achieve better results with a separate flash unit. Simply fit a compatible Speedlight directly on the accessory shoe or via a remote connecting cord.

To get the best from the flash system requires a greater understanding of how the camera interprets what it sees. So, throughout this chapter we will explore not just the Nikon flash system, but also some of the fundamentals to using flash, including calculating flash exposure and applying flash in the field.

The Nikon flash system

The flash system available from Nikon is quite comprehensive and can also be supplemented by non-proprietary systems produced by manufacturers such as Metz and Sunpak. In this section I will

Flash terminology

The guide number of the flash unit is a measure of its light output – the greater the number the greater the intensity of the flash. As well as providing a guide to the power of a given flashgun, guide numbers are needed to calculate flash exposure in manual exposure mode. Flash coverage refers to the focal length of the lens or lenses the flashgun is designed to work with. Recycling time is the amount of time it takes for the flash to recharge after firing. This is particularly important if you are operating the D70 in continuous shooting mode.

concentrate solely on the Nikon system, and some of the more useful accessories within the range.

The D70 has an ISO-type hotshoe for direct mounting of dedicated electronic flash units, such as the SB-600 and SB-800. An AS-15 adapter can also be attached to allow flash accessories to be attached via a sync lead. When no flash is mounted it can also be used to attach other useful accessories, such as a spirit level.

Built-in Speedlight

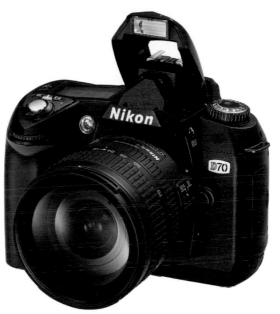

The built-in speedlight unit has a guide number of 49ft (15m) at ISO-E 200 and a sensitivity range of ISO-E 200–1600. It is compatible with most Nikon CPU lenses from 20–300mm (see table on page 144), although the 3D colour matrix balanced fill flash will only operate with D- and G-type lenses. The D70's Speedlight is also compatible with Ai-S, Ai and Ai-modified non-CPU lenses with a focal length of between 20 and 200mm, with some restrictions and only in certain modes.

It is fair to say that the unit works well for general, everyday use at its default settings but you may eventually find that its lack of power and the limited movement it offers will see you opting for one of Nikon's more powerful external Speedlights, which are covered later in this chapter.

Compatible lenses

While the built-in Speedlight can be used with any Nikon CPU lens with a focal length between 20 and 300mm, it may be unable to light the entire frame if lenses are used at the zoom settings stated and below the minimum ranges shown on page 144.

The D70 comes with a Speedlight flash unit built into the penta-mirror housing and this is likely to be many people's starting point.

Note
When a non-CPU type lens is used with the D70, the built-in Speedlight can only be operated in MANUAL flash exposure mode (see CS-19). If TTL mode is selected in CS-19 then the shutter release will be disabled when the flash unit is raised and the flash ready indicator (⚡) in the viewfinder and ⚡ icon in the control panel will blink.

Lens	Zoom setting	Min. flash range
AF-S DX ED 12–24mm f/4G IF-ED	20mm	8ft 2in / 2.5m
	24mm	3ft 3in / 1.0m
AF-S 17–35mm f/2.8D ED	20mm + 24mm	8ft 2in / 2.5m
	28mm	3ft 3in / 1.0m
AF-S DX 17–55mm f/2.8G IF-ED	20mm + 24mm	8ft 2in / 2.5m
	28mm	4ft 11in / 1.5m
	35mm	2ft 4in / 0.7m
AF 18–35mm f/3.5–4.5D ED	20mm	6ft 6in / 2.0m
	24mm	2ft 4in / 0.7m
AF 20–35mm f/2.8D	20mm	4ft 11in / 1.5m
	24mm	3ft 3in / 1.0m
AF-S VR 24–120mm f/3.5–5.6G IF-ED	24mm	2ft 7in / 0.8m
AF-S 28–70mm f/2.8D IF-ED	28mm	9ft 10in / 3.0m
	35mm	3ft 3in / 1.0m
AF-S VR 200–400mm f/4G	200mm	13ft 1in / 4.0m
	250mm	8ft 2in / 2.5m

The following restrictions apply with non-CPU type lenses:

Ai-S 25–50mm f/4, Ai 25–50mm f/4 and Ai-S 35–70mm f/3.5 lenses can be used at the 35mm focal length setting at a range of 3ft 3in / 1.0m or above.

Ai 50–300mm f/4.5, Ai modified 50–300mm f/4.5, Ai-S ED 50–300mm f/4.5 and Ai-modified 85–250mm f/4 can be used at focal length setting of 135mm and above.

Ai 50–300mm f/4.5 ED can be used at focal length setting of 105mm and above.

Ai-S ED and Ai ED 200mm f/2 are incompatible.

Operating the built-in Speedlight in i-TTL mode

i-TTL is, at the time of writing, a new flash technology introduced along with the new Creative Lighting System (CLS), which takes advantage of the enhanced communication capabilities of digital cameras and provides increased flash shooting functionality when used with the D70. In i-TTL flash mode, monitor pre-flashes are fired continually and exposure is less susceptible to the affects of ambient light than is the case with standard TTL flash.

When used in conjunction with CPU-type lenses, the built-in Speedlight operates in one of two i-TTL flash control modes:

i-TTL balanced fill flash for DSLR

This mode is automatically selected unless the D70 is set to MANUAL exposure mode or the metering mode is set to spot metering in auto multi program, shutter-priority or aperture-priority modes.

The Speedlight emits a series of imperceptible pre-flashes immediately before the main flash fires, which are reflected from all areas of the frame and recognized by the 1,005-pixel RGB sensor. These pre-flashes are analysed by the camera in conjunction with information gathered from the colour matrix metering system and, if D- or G-type lenses are attached, distance information. The flash

Tip

In CS 19 (see page 118) TTL, Manual or Commander flash modes can be selected from the menu. When MANUAL mode is selected the guide number of the built-in Speedlight increases to 17m (56ft) at ISO-E 200. Commander mode can be used for wireless off-camera flash photography in conjunction with the new (at the time of writing) SB-800 or SB-600 Speedlights.

output is adjusted to give a natural-looking balance between the main subject and the ambient background lighting.

Standard i-TTL flash for DSLR

When the D70 is set up so that i-TTL balanced fill flash doesn't operate (i.e. when the D70 is set to manual exposure mode or the metering mode is set to spot metering in auto multi program, shutter-priority or aperture-priority modes) then standard i-TTL flash for DSLR automatically activates. In i-TTL flash for DSLR mode the flash output is adjusted to ensure the main subject is correctly exposed but background brightness is removed from the equation.

1) Select an exposure mode by rotating the mode dial to the appropriate setting (see page 22).

If using the built-in Speedlight in **VP** ☝AUTO☝, 🎿, 🌷 and 🏔 modes, go to step 4.

2) Select a metering mode (see page 84). In **P, S** and **A** modes, the metering mode will determine the type of flash control used by the D70. For i-TTL balanced fill flash for DSLR, select either matrix or centre-weighted metering modes.

Standard i-TTL flash for DSLR is automatically selected if the D70 is set to manual exposure mode or the metering mode is set to spot metering in auto multi program, shutter-priority auto or aperture-priority auto modes.

3) To activate the built-in Speedlight, press the Speedlight lock-release button on the side of the penta-mirror. The unit will begin to charge as soon as it is raised and, when ready, the flash-ready indicator will light up.

4) Press the 🔆 button and simultaneously rotate the main command dial to select your preferred flash sync mode (see page 147). The flash sync icons are shown in the control panel.

⚠ Common errors

Sometimes, when the built-in Speedlight is raised but is not used, the ISO auto (see page 112), will not function correctly. Download the latest firmware update to correct this problem, see page 48.

Tip
The top LCD panel can be illuminated to aid visibility in dim light. Press the illumination button and a blue–green light will illuminate the LCD panel. The light will automatically switch off after eight seconds or after the shutter release is fired.

Note
The combination electronic/ mechanical shutter enables a very high flash sync speed of 1/500sec. This is considerably higher than a number of the D70's competitors and enables high shutter speeds to be used in conjunction with flash without flash cut-off occurring.

Flash sync modes

To set the desired sync mode, rotate the main command dial while pressing the flash sync mode button. Note that some modes are only available with certain exposure modes, (see pages 85–9).

Front curtain sync and auto front curtain sync

Front curtain sync is used in the majority of conditions and the flash fires at the beginning of the shutter cycle, the advantage is that you capture scene or subject immediately as you see it through the viewfinder, which is especially important when photographing people. In auto multi program or aperture-priority auto modes the camera will set the shutter speed between 1/60sec and 1/500sec, (1/125sec and 1/500sec in 🌷 mode), depending on the level of light.

Slow sync and auto slow sync

One of the problems with flash can be the limited distance that light from a flash unit travels and the abrupt fall off of the light at longer distances. At night and in low light conditions, this can cause background areas to greatly underexpose and appear very dark or even completely black. Selecting slow or auto slow sync mode helps to create a more even exposure over the entire scene by selecting much slower shutter speeds, allowing the CCD to expose the areas lit by natural light for longer. Slow sync mode will only work in auto multi program or aperture-priority exposure modes, while auto slow sync works in 👤★ mode. I recommend attaching the camera to a tripod to avoid blur caused by camera shake.

Rear curtain sync

Selecting rear curtain sync mode will fire the flash unit just before the shutter closes, (as opposed to at the beginning of the sequence as occurs when front curtain sync is selected). The principal reason for this is that when photographing fast-moving subjects you generally want any trailing light to appear behind the subject rather than in front of it.

In **S** and **M** modes standard rear curtain sync mode operates as above. However, in **P** and **A** exposure modes, slow rear curtain sync is set automatically. Slow rear curtain sync combines the attributes of rear curtain sync mode with slow sync mode. This means that subjects will be correctly exposed – with the trailing light effect – while slow sync will leave the shutter open long enough for a dark background to be correctly exposed as well.

OFF

Select OFF in flash sync mode to turn the automatic flash off. In ◤, ⚞ and ⊞ modes the flash is always set to OFF.

Red-eye reduction, auto with red-eye reduction, slow sync with red-eye reduction and auto slow sync with red-eye reduction

Red-eye, or green-eye in the case of some animals, is a particular problem caused by on-camera flashlight reflecting directly off the retina of the eyes. This problem is greater the bigger the pupils are. Red-eye reduction works by lighting the AF-assist illuminator for approximately one second before the flash and shutter fire to reduce the size of the pupils, helping to eliminate the problem. Does it work? Kind of, though it is far better to use a separate flash unit, see page 158, held off-camera at an angle of around 45° to the subject. One of the main limiting factors with red-eye reduction is the delay in the shutter firing, which can make photographing moving subjects in this mode practically impossible.

Combining slow sync with red-eye reduction is useful when photographing portraits of people or animals where you want the background to be part of the picture. The red-eye reduction will help eliminate the problem of red-eye, while the slow sync will allow the background area to be correctly exposed. This mode will work only in auto multi program and aperture-priority auto modes and, because of the slow shutter speeds, I would suggest using a tripod. You'll also need to make sure that your subject remains very still during exposure.

Note Some lenses can block the red-eye reduction lamp, interfering with its operation.

Flash sync mode	Compatible exposure modes	Comments
Front curtain sync	**P, S, A, M**	
Red-eye reduction	**P, S, A, M**	
Slow sync + red-eye reduction	**P, A**	If **S** or **M** mode is selected after this option has been selected in **P** or **A** mode, flash sync will automatically be set to red-eye reduction sync
Slow sync	**P, A**	If **S** or **M** mode is selected after this option has been selected in **P** or **A** mode, flash sync will automatically be set to front curtain sync
Rear curtain sync	**P, S, A, M**	In **P** and **A** modes, flash sync will be set to slow rear curtain sync when the ⚡ button is released. Rear curtain sync cannot be used with studio flash set-ups as correct synchronization cannot be obtained.
Auto front curtain sync	AUTO 📷, 🏃, 🌷	
Auto + red-eye reduction	AUTO 📷, 🏃, 🌷	
Auto slow sync	🌃	
Auto slow sync + red-eye reduction	🌃	
Off	AUTO 📷, 🏃, 🌷, 🌃, 🏞, 🏃, and 🌇	

To check exposure **B**

1) Press the shutter-release button halfway. In vari-program AUTO 📷, 🏃, 🌷 and 🌃 modes the built-in Speedlight will pop up automatically if needed.

AVAILABLE APERTURE/SHUTTER SPEED COMBINATIONS IN EACH OF THE EXPOSURE MODES:

Exp. Mode	**P**
Shutter speed	Set automatically by the D70 in the range of 1/500–1/60sec
Aperture	Set automatically by the camera
Comments on shutter speed	The lower limit for shutter speed is set in CS 21 (see page 119). However, at flash sync settings of slow sync, slow rear curtain sync and slow sync with red-eye reduction, the D70 may select shutter speeds as slow as 30 seconds, irrespective of the value set in CS 21
Exp. Mode	**S**
Shutter speed	Shutter speed selected by user in the range 1/500–30 seconds
Aperture	Set automatically by the camera
Comments on shutter speed	If the shutter speed is set to greater than 1/500sec the camera will automatically set the value to 1/500sec when the in-built Speedlight is activated or an external Speedlight unit is attached and turned on
Exp. Mode	**A**
Shutter speed	Set automatically by the D70 in the range of 1/500–1/60sec
Aperture	Aperture selected by the user
Comments on shutter speed	The lower limit for shutter speed is set in CS 21 (see page 119). However, at flash sync settings of slow sync, slow rear curtain sync and slow sync with red-eye reduction, the D70 may select shutter speeds as slow as 30 seconds, irrespective of the value set in CS 21
Comments on aperture	The range of the built-in Speedlight varies with the aperture setting. See the table on page 154

Exp. Mode	**M**
Shutter speed	Selected by user in the range 1/500–30 seconds
Aperture	Selected by the user
Comments on shutter speed	If the shutter speed is set to greater than 1/500sec the camera will automatically set the value to 1/500sec when the built-in Speedlight is activated or an external Speedlight unit is attached and turned on
Comments on aperture	The range of the built-in Speedlight varies with the aperture setting. See the table on page 154

Exp. Mode	**AUTO**, 🏃
Shutter speed	Set automatically by the D70 in the range of 1/500–1/60sec
Aperture	Set automatically by the camera

Exp. Mode	🌷
Shutter speed	Set automatically by the D70 in the range of 1/500–1/125sec
Aperture	Set automatically by the camera

Exp. Mode	📷
Shutter speed	Set automatically by the D70 in the range of 1/500–1sec
Aperture	Set automatically by the camera

Exp. Mode	🏔, 🏃, 🌄
Shutter speed	N/A
Aperture	N/A

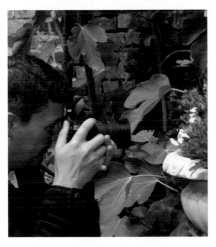

Notes

The built-in Speedlight cannot be raised and fired manually in 🅰🆄🆃🅾 📷 🏃, 🌷 and 🖼 modes. If the unit is raised it will only activate when additional lighting is perceived by the D70 as being required.

1) The flash-ready indicator must light before a picture can be taken. When the ⚡ appears in the viewfinder, take the picture. Keep an eye on the flash-ready light: if it blinks for around three seconds after exposure then the built-in Speedlight has discharged at full power and there is a chance that your picture will be underexposed. To check, view the resulting image(s) on the monitor and, if needs be, adjust the settings and retake the picture.

If the shooting mode is set to continuous only a single picture will be taken when the shutter release button is pressed when the built-in Speedlight is in operation.

The vibration reduction function on VR lenses remains inactive when the shutter-release button is pressed halfway and the built-in Speedlight is charging.

To protect the flash, the built-in Speedlight may turn off briefly after several consecutive shots.

Tip
The lens hood of some Nikon lenses can obstruct the flashlight from the built-in Speedlight and should be removed before taking a picture using the built-in flash unit.

The range of the built-in Speedlight varies with the ISO-E and aperture settings. The table below provides a guide to flash range. Note that the minimum distance the flash can be operated reliably is 0.6m / 2'.

Aperture at ISO equivalent of										Range	
200	250	320	400	500	640	800	1000	1250	1600	ft	m
2	2.2	2.5a	2.8	3.2	3.5	4	.5	5	5.6	3ft 3in–25ft 3in	1.0–7.7
2.8	3.2	3.5	4	4.5	5	5.6	6.3	7.1	8	2ft 4in–18ft 1in	0.7–5.5
4	4.5	5	5.6	6.3	7.1	8	9	10	11	2ft–13ft 1in	0.6–4.0
5.6	6.3	7.1	8	9	10	11	13	14	16	2ft–12ft 6in	0.6–3.8
8	9	10	11	13	14	16	18	20	22	2ft–6ft 3in	0.6–1.9
11	13	14	16	18	20	22	25	29	32	2ft–4ft 7in	0.6–1.4
16	18	20	22	35	29	32				2ft–2ft 11in	0.6–0.9
22	25	29	32							2ft–2ft 4in	0.6–0.7

MAXIMUM APERTURE SETTINGS

In P, 📷AUTO, 🏃, 🏔, 🌷 modes, the maximum aperture is restricted according to the ISO-E setting used.

Mode	Maximum aperture at ISO equivalent of									
	200	250	320	400	500	640	800	1000	1250	1600
P 📷AUTO 🏃 🏔	2.8	3	3.2	3.3	3.5	3.8	4	4.2	4.5	4.8
🌷	5.6	6	6.3	6.7	7.1	7.6	8	8.5	9	9.5

Flash exposure compensation

Flash exposure compensation can be used to make subtle adjustments, in **P**, **S**, **A** or **M** exposure modes by adjusting the power output of the built-in Speedlight to fine-tune automatic flash exposures.

Increasing the exposure by selecting positive exposure compensation will increase the illumination from the flash unit and is often used when the main subject is much darker than the background. Negative exposure compensation will reduce power output and can be used, among other things, for evening the tonal range between a bright subject and a dark background.

To set exposure compensation

1) Select **P**, **S**, **A** or **M** exposure mode via the mode dial and set the appropriate flash sync mode (see pages 147–9).

2) Press the 🔆 button (**12**) and simultaneously rotate the sub-command dial to set the flash exposure compensation value. Flash exposure compensation can be set between –3 EV (reduce flash power output) to +1 EV (increase flash power output) in increments of 1/3 EV.

3) When flash exposure compensation is set the 🔆 icon appears in the control panel and viewfinder. To confirm the current level of flash exposure compensation set, press the 🔆 button.

4) Setting flash exposure compensation to ±0 will restore normal flash operation.

⚠ Common errors

Flash exposure compensation is not reset when the D70 is turned off, so remember to reset it to ±0 once you have finished using it. Otherwise, subsequent pictures may turn out incorrectly exposed.

Tip
Incremental changes to flash exposure compensation can be set to 1/2 EV steps in CS 9.

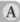

Locking flash power output has the same effect as locking exposure. It allows you to expose for an off-centre subject and recompose the frame without adversely affecting the flash exposure setting.

1) To turn FV lock on, select FV lock for custom setting 15.

2) Set exposure mode and flash sync mode in the normal way (see pages 22 and 147).

3) Position the subject in the centre of the frame and activate AF by pressing the shutter-release button halfway.

4) Once the flash-ready indicator lights in the viewfinder, press the AE-L/AF-L button (**27**). The built-in Speedlight will emit a monitor pre-flash to determine flash power output and lock the value until the AE-L/AF-L button is pressed again. **EL** will appear in the viewfinder.

5) Recompose the picture and press the shutter-release button to expose the image.

Notes

FV lock can also be operated with the external SB-800 and SB-600 flash units in TTL mode (the SB-800 can also be used in AA mode).

While the D70 has no PC socket for attaching external flash, you can fit a wireless trigger unit to the accessory hotshoe.

Using optional Speedlights

The D70 is part of Nikon's Creative Lighting System, it is fully compatible with the SB-800 and SB-600 Speedlights and offers a combination of simplicity and versatility.

Fitting an optional Speedlight

To fit an optional Speedlight to the D70's accessory shoe, first turn off the camera and the flash unit. Slide the flash unit into the accessory shoe, then turn the mounting foot lock lever (if applicable) to secure the unit.

Using bounce flash

With flash units with adjustable heads you can soften the effects of flash by bouncing it off a ceiling or wall.

1) Set the D70 exposure dial to either **A** or **M**.

2) Select centre-weighted or matrix metering mode.

3) Set the mode on the flash unit to TTL, AA, or non-TTL auto flash.

4) Select the aperture.

5) Tilt or swivel the flash head.

6) Wait for the ready light to appear on the flash unit before shooting.

Using multiple Speedlights

Advanced Wireless Flash with the D70 allows the SB-800 and SB-600 units to be used in a multiple flash system to manipulate the way shadows appear.

1) Set each unit to Master (control and flash), Commander (control no flash), or Remote (flash only).

2) Choose the group and channel for each flash unit (see flash manual).

3) Adjust the Master/Commander flash's settings as described earlier in the chapter.

4) Arrange the units and shoot.

SB-800

The SB-800 is fully compatible with the full range of the D70's functions. It forms the cornerstone of Nikon's Creative Lighting System, supports the latest Advanced Wireless Technology and offers a great deal of photographic versatility.

Guide number
(ISO-E 200, m/ft) 53/174

Recycling time
2.7 seconds with quick recycle pack, 6 seconds with AA batteries

Number of flashes
150 at full output

Flash coverage 24–105mm, 14 and 17mm with built-in adaptor, 14mm with diffusion dome

Dimensions (w x h x d)
70.6 x 127.4 x 91.7mm

Weight 350g (without batteries)

Included Accessories SD-800 quick recycle battery pack, SW-10H diffusion dome, AS-19 speedlight stand, SJ-800 colour filter set, SS-800 soft case

SB-600

The SB-600 was released at the same time as the Nikon D70. While, it offers slightly less versatility than the SB-800 it is fully compatible with the Creative Lighting System and Advanced Wireless Technology.

Guide number
(ISO-E 200, m/ft) 39/128

Recycling time
3.5 seconds with AA batteries

Number of flashes
200 at full output

Flash coverage 24–85mm

Dimensions (w x h x d)
68 x 123.5 x 90mm

Weight 300g (without batteries)

Included Accessories
AS-19 speedlight stand, SS-600 soft case

SB-800 and SB-600 compatibility

	TTL	BL	AA	A	GN	M	↯	REAR	◉	FCI	FV	AF	ZOOM	ISO AUTO
SB-800	TTL	BL	AA	A	GN	M	↯	REAR	◉	FCI	FV	AF	ZOOM	ISO AUTO
SB-800 AWL	TTL	BL	AA	A		M		REAR			FV			
SB-600	TTL	BL				M		REAR	◉	FCI	FV	AF	ZOOM	ISO AUTO
SB-600 AWL	TTL	BL				M		REAR			FV			

Non-i-TTL Speedlight compatibility

While, the SB-800 and SB-600 Speedlights provide the best compatibility with the D70, other Speedlights still offer a limited range of functions.

	A	M	↯	REAR	SLOW
SB-80DX	A	M	↯	REAR	SLOW
SB-50DX		M		REAR	SLOW
SB-30	A	M		REAR	SLOW
SB-29/29s		M		REAR	SLOW
SB-28/28DX	A	M	↯	REAR	SLOW
SB-27	A	M		REAR	SLOW
SB-26	A	M	↯	REAR	SLOW
SB-25/24	A	M	↯	REAR	SLOW
SB-23		M		REAR	SLOW
SB-22/22s	A	M		REAR	SLOW
SB-21B		M		REAR	SLOW
SB-20	A	M		REAR	SLOW
SB-16A/B	A	M		REAR	SLOW
SB-15	A	M		REAR	SLOW

Symbol	Meaning	Symbol	Meaning
TTL	i-TTL flash	FCI	Flash Colour Information
AA	Auto aperture	FV	FV lock
A	Non-i-TTL automatic control	AF	AF-Assist illuminator
BL	Balanced fill flash	SLOW	Slow sync
GN	Range-priority manual	ZOOM	Automatic power zoom
M	Manual control	ISO AUTO	ISO sensitivity automatically adjusted
↯	Repeating flash		
REAR	Rear curtain sync		
◉	Red-eye reduction*		

*While the red-eye reduction lamp will light, pre-flash will not work with non-i-TTL flashes

Chapter **5**

Close-up with the D70

The breadth of the Nikon system and the versatility of the digital format makes the D70 an ideal camera to use for close-up photography. While the fundamental rules of photography apply equally to the close-up world, the equipment used is often very specialized.

Reproduction ratio

One of the most important aspects of close-up photography is the reproduction ratio. This denotes the relationship between the actual size of the subject and the size at which it is reproduced on the CCD. A reproduction ratio of 1:1, for example, means that the image on the CCD is the same size as the subject in real life. A reproduction ratio of 1:1 or greater is referred to as macro photography. The reproduction ratio is determined by the distance between the CCD plane and the subject combined with the lens' focus setting.

Free working distance

Another term that you will become familiar with in close-up photography is free working distance. This means the distance between the front element of the lens and the subject. At very close quarters a living subject may become stressed and non-cooperative. Also, the close proximity of the lens may affect the lighting of the subject.

Managing depth of field

One of the greatest challenges you'll face in close-up photography is managing depth of field. In close-up work depth of field is very shallow and is affected by the reproduction ratio and aperture. The greater the reproduction ratio and the larger the aperture, the shallower the depth of field.

The D70 close-up system

The diagram on page 164 illustrates the effect on reproduction ratio of different accessory combinations.

The D70's CCD

The D70's CCD provides a 1.5x effective focal length multiplier. The effect of the smaller CCD is not actually to increase focal lengths, but to decrease the picture angle, this gives the appearance of increased focal length but maintains the reproduction ratio of the lens. This means that the D70's sensor gives you a greater free working distance.

REFRACTED GERBERA
The management of depth of field is
one of the most critical decisions in
macro photography. Here a shallow
deph of field is used to keep the image
in the water droplet sharp against the
soft backdrop of the flower.

Reproduction ratios with Nikon accessories

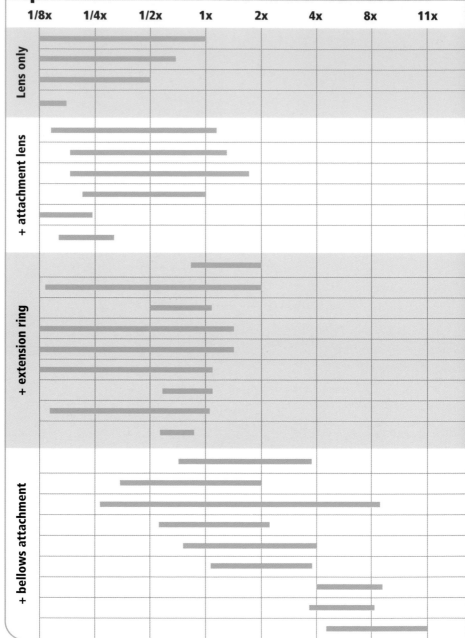

AF Micro-Nikkor 60mm f/2.8D, 105mm f/2.8D, 200mm f/4D IF-ED

AF Zoom-Micro Nikkor 70–180mm f/4.5–5.6D ED

PC Micro-Nikkor 85mm f/2.8D

AF Nikkor 50mm f/1.8D

AF Micro-Nikkor 60mm f/2.8D + close-up attachment lens no. 5T

AF Micro-Nikkor 105mm f/2.8D + close-up attachment lens no. 3T

AF Micro-Nikkor 200mm f/4D IF-ED + close-up attachment lens no. 6T

AF Zoom-Micro Nikkor 70–180mm f/4.5–5.6D ED + close-up attachment lens no. 6T

AF Nikkor 50mm f/1.8D + close-up attachment lens no. 1

AF Nikkor 50mm f/1.8D + close-up attachment lens no. 2

AF Micro-Nikkor 60mm f/2.8D + auto extension ring PN-11

AF Micro-Nikkor 60mm f/2.8D + auto extension rings PK-11A/12/13

AF Micro-Nikkor 105mm f/2.8D + auto extension ring PN-11

AF Micro-Nikkor 200mm f/4D IF-ED + auto extension rings PK-11A/12/13

AF Zoom-Micro Nikkor 70–180mm f/4.5–5.6D ED + auto extension rings PK-11A/12/13

PC Micro-Nikkor 85mm f/2.8D + auto extension rings PK-11A/12/13

PC Micro-Nikkor 85mm f/2.8D + auto extension rings PN-11

AF Nikkor 50mm f/1.8D + auto extension rings PK-11A/12/13

AF Nikkor 50mm f/1.8D + macro adapter ring BR-2A

AF Micro-Nikkor 60mm f/2.8D + bellows PB-6

AF Micro-Nikkor 105mm f/2.8D + bellows PB-6

AF Zoom-Micro Nikkor 70–180mm f/4.5–5.6D ED + bellows PB-6

PC Micro-Nikkor 85mm f/2.8D + bellows PB-6

AF Nikkor 50mm f/1.8D (normal) + bellows PB-6

AF Nikkor 50mm f/1.8D (reverse) + bellows PB-6

AF Nikkor 50mm f/1.8D (normal) + bellows PB-6 + extension bellows PB-6E

AF Nikkor 50mm f/1.8D (reverse) + bellows PB-6 + extension bellows PB-6E

AF Nikkor 20mm f/2.8D (reverse) + bellows PB-6 + Macro Adapter Ring BR-5

Lenses

Nikon currently produces five micro lenses for close-up work. These are one of the more expensive options for close-up photography, however they do offer extremely high quality. Lenses with longer focal lengths allow you a greater free working distance, and are particularly useful for nature photography. As well as four autofocus lenses, see page 186, Nikon also produces the PC Micro-Nikkor 85mm f/2.8D lens, which offers tilt and shift perspective control, allowing you greater management of perspective distortions and depth of field. They are also compatible with the D70's 3D colour matrix metering system.

AF Zoom-Micro Nikkor 70–180mm f/4.5–5.6D ED

Note
Using a teleconverter, see page 183, will leave the reproduction ratio unchanged but will give you a greater free working distance.

Close-up attachment lenses

Close-up attachment lenses screw onto the front of your lens, like a filter. They are an inexpensive tool for close-up photography, though image quality will be compromised.

Seven attachment lenses are available numbered 0–6T. Numbers 0, 1 and 2 are for use with lenses up to 55mm focal length. Numbers 3T–6T are two-element achromats for use with telephoto lenses. As a guide, the higher the number the closer you can focus. Filters 0, 1, 2, 3T and 4T all have a 52mm thread, while 5T and 6T have a 62mm thread.

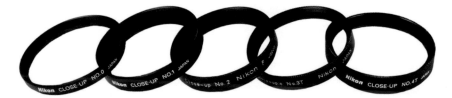

Auto extension rings PK/PN

Extension rings provide a combination of quality and convenience. They fit between the lens and the camera, extending the lens from the lens mount and magnifying the image. They come in different sizes and can be used in isolation or combination. Focusing with any of the rings must be done manually, although the electronic rangefinder will work

with lenses that have a maximum effective aperture of f/5.6 or faster. The only exposure mode available is manual and the only metering options are centre-weighted and spot..

The three extension rings shown are the PK-11A, PK-12 and PK-13, with 8mm, 14mm and 27.5mm of extension respectively. Not shown is the PN-11, which offers 52.5mm of extension and a built-in tripod collar lock.

Note

Some pre-AI lenses press against the aperture-indexing tab by the lens mount. You can bypass this problem with an extension ring.

Bellows focusing attachment PB-6

Bellows provide the greatest degree of control over reproduction ratio. The bellows fits between the lens and the camera, extending the lens from the mount. Unlike extension rings you can control the exact

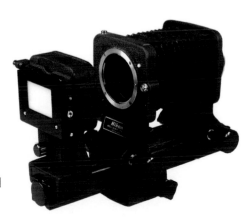

This image also shows the PS-6 slide copying attachment, this addition to the PB-6 is a useful tool if you don't have a scanner and want to record old slide images digitally.

extension by adjusting the bellows along the rail (extension range is 48–208mm). In combination with other accessories, bellows can gain a reproduction ratio of up to 11x. As with the Nikon auto extension rings, focusing must be performed manually (although the electronic rangefinder is compatible with CPU lenses that have a maximum effective aperture of f/5.6 or wider).

Using the PB-6 bellows unit with the D70 means that all TTL metering modes are unavailable, and exposure modes other than manual will not function.

Note
Using spacers when using the D70 with the bellows will give the camera more movement.

Inversion rings

Lenses that are used in their normal orientation render a comparatively large subject as a small image. To reverse this effect and achieve some extremely large reproduction ratios (see table on page 164) you can invert lenses and attach them to the D70 using an inversion ring.

Correct macro **technique**

Dealing with large reproduction ratios means that any mistakes you or the D70 make will be magnified. While the D70's close-up vari-program mode is a good introduction for those who are new to macro photography it doesn't give the flexibility to make images that are out of the ordinary.

Exposure

The D70's metering system works with the macro lenses discussed above, it will also not be affected by the use of close-up attachment lenses. However, auto extension rings, inversion rings and the PB-6 bellows unit are all incompatible with the D70's metering systems.

Normally in macro photography the aperture has a far greater effect on the final image than the shutter

speed. This is because subjects will often be stationary and the camera mounted on a tripod. Conversely, aperture has a much greater effect on depth of field at short working distances and so it is important that you maintain full control over it.

Try using the D70 in aperture-priority mode to control depth of field, if the accessories that you are using allow it. Alternatively switch to manual exposure mode for full control of exposure. If you do switch to manual remember that at high magnifications the f-stop as a measure of exposure becomes inaccurate, see table below.

Set the ISO-E to 200 for maximum quality and minimum noise, see page 55. To ensure that your images are correctly exposed make full use of the D70's white balance bracketing (see page 61), exposure bracketing (see page 93), and playback image and histogram (see page 108) functions.

Reproduction ratio	Compensate by
1:1	+ 2 stops
1.5:1	+ 2 1/2 stops
2:1	+ 3 1/3 stops
3:1	+ 4 stops

* This table is only a guide and the variance in exposure depends on the combination of accessories and lenses.

Tip
Depth of field can be hard to judge using the depth-of-field preview button as the viewfinder will dim when the aperture is stopped down. You can bypass this by using the playback monitor and the playback zoom function to review which areas of the image are acceptably sharp and then adjust the aperture and shoot again accordingly.

Optimum aperture

At macro magnifications the quality of the lens becomes more apparent. A lens' inherent flaws (such as chromatic aberration) are most obvious at its widest aperture, conversely the detrimental effects of diffraction are most apparent at its narrowest aperture. At some point in the mid-range of a lens' apertures these two problems will coincide at relatively low levels, which means that the image is at its highest quality. This is known as the optimum or critical aperture. It is often considered to be f/8, however it varies from lens to lens.

Focus

Even when autofocus is still possible it can become inaccurate and unpredictable at large reproduction ratios. If you want complete control over focus, switch the D70 to its manual focus mode. This is also very useful for selective focusing when only part of the image is in focus for creative reasons.

Autofocus will work with Nikon's Micros lenses, with the exception of the PC Micro-Nikkor 85mm f/2.8D lens, which is manual focus. They are all compatible with the D70's electronic rangefinder function although it is worth noting that when the PC Micro-Nikkor 85mm f/2.8D lens has tilt and/or shift applied it is no longer compatible.

Auto extension rings, inversion rings and the PB-6 bellows will not work with autofocus, although the D70's electronic rangefinder is enabled when the accessories are used with lenses providing a maximum effective aperture of f/5.6 or wider.

Photo by James Evans

Extremely effective images can be achieved by filling the frame with the subject – this is a very popular method for flower photography. However, the viewfinder of the D70 only covers 95% of the image, shown by the dotted outline on the image above. Remember this when you are composing a shot and check the corners of the playback image to make doubly sure.

Image settings

Because macro photography is such a hard discipline to get to grips with, it makes sense to shoot in the mode that offers you the most versatility.

Switch to NEF RAW (see page 52) and select the Adobe RGB colour mode, see page 68, as they allow you to correct any imperfections later in imaging applications.

Combating aliasing and moiré

Aliasing and moiré, can be a problem at large magnifications, especially when subjects display repeating high-contrast patterns. The interference of repetitive patterns results in a loss of resolution and colour fringing, known as moiré. While high contrast can lead to a loss of edge definition, known as aliasing. If the low-pass filter that the D70 is fitted with doesn't correct the problem sufficiently you may be left with an unpleasant effect in the final image. Try changing the lighting conditions, the camera position (moving back and zooming in to achieve the same reproduction ratio) and camera angle. If all else fails then make sure you are recording your images in NEF RAW format (see page 52); this gives you the full amount of information to correct your images later in application.

⚠ Common errors

Some criticism has been made of the D70 because its low-pass filter doesn't appear to be as strong as on previous Nikon digital cameras. Because the anti-aliasing properties of the D70's low-pass filter have a detrimental effect on image sharpness Nikon have invested an anti-aliasing algorithm into the NEF files that are produced. In order for the software part of the anti-aliasing process to take effect the files must be opened in a fully compatible program such as Nikon Capture Version 4.1 or later, or Adobe Photoshop.

Note that the mirror lock-up function on the D70 is designed to give access to the low-pass filter for cleaning. It is not the same function as featured on a number of other cameras, which is designed to minimize the effects of camera shake at large magnifications.

This diagram shows how the interference of two patterns – in the case of the D70 a pattern on the subject and the pattern of photodiodes on the CCD – can combine to produce a moiré effect.

Chapter **6**

Useful lenses

The lens is the most important part of any camera. It is better to attach a high-quality lens to an inexpensive camera body than vice versa. It is the lens, more than any other single factor in photography, that affects the quality of the final image – and this is probably even truer for digital photography.

The D70 uses the famous Nikon F-mount for attaching lenses. In theory, this means the D70 can be used with any Nikon lens made since 1959. There are, however, some exceptions to this rule and some lenses may need special alterations before they can be used with the D70. For a list of compatible lenses refer to the lens compatibility chart on page 184.

Nikon has one of the most extensive lens systems of any camera manufacturer. It is not feasible in this book to discuss all the available lenses. What I have attempted to do here is explain some of the main characteristics of the modern Nikon lens and identify some of the most useful lenses available for the D70 that you are likely to use outside of the most specialized areas of photography, in particular the digital specific DX range of zoom optics.

Tele-centric (DX) lens design

The way that a digital photosensor records light is different to film, and Nikon has designed a new series of lenses specifically for its range of digital SLRs.

In film photography, light falling on the film is recorded accurately across the frame irrespective of the angle of incidence. The photosensor used in a digital camera, however, is a microchip with photodiodes laid out at regular intervals on a grid. The photodiodes sit in depressions meaning that light can only reach them effectively if it comes through the lens from straight ahead.

This means that if a 35mm film format lens is attached to a digital camera body, insufficient light at the edges of the CCD can result in a loss of image quality. The wider the angle of view of the lens the worse the problem becomes.

To combat this problem, Nikon began designing lenses specifically for digital cameras. These telecentric DX lenses are designed to ensure that light falls on the CCD as close to 90°, thereby maximizing image quality.

Modern lens technology

Described below are some of the main optical features that Nikon now incorporate when designing Nikkor lenses.

AI-S **Aperture indexing shutter meter coupling**	The AI-S design introduced a standardized aperture stop down function, which is essential to achieving reliable and accurate shutter speeds in **S** and **P** exposure modes.
ASP **Aspherical lens elements**	ASP lenses are effective in eliminating the problem of coma and other types of aberration. **Main benefit** Particularly useful for correcting distortion in wideangle lenses, even at large apertures.
CRC **Close-range correction system**	CRC lenses use a 'floating element' design that allows each element to move independently to achieve focus. **Main benefit** Improves quality at close focusing distances and increases the focus range in wideangle, fisheye, micro and some medium telephoto lenses.
D **Distance information**	D-type and the new G-type Nikon lenses relay subject-to-camera distance information to the D70 for use with 3D matrix metering exposure calculations. **Main benefit** Improves accuracy of TTL readings.
DC **Defocus-image control**	Defocus-image control lenses are specialist lenses particularly useful to the portrait photographer. DC technology allows the photographer to control the degree of spherical aberration in the foreground or background by moving a rotating ring. **Main benefit** An out-of-focus blur can be created that is ideal for portraiture.

ED **Extra-low** **dispersion** **glass**	ED glass minimizes chromatic aberration, a type of image and colour dispersion that occurs when light rays of varying length pass through optical glass. **Main benefit** Improves sharpness and colour correction.
G-type lenses	Because modern Nikon SLRs are designed with a sub-command dial that controls aperture, Nikon launched the G-type lens that dispensed with the aperture ring on the lens barrel. The main advantage in this design is reduced size and they are fully compatible with the D70. G-type lenses also provide distance information for the 3D colour matrix metering system.
IF **Internal** **focusing**	Internal focusing allows a lens to focus without changing its size. All internal optical movement is limited to the interior of the lens barrel, which is non-extending. **Main benefit** Produces a lens that is more compact and lightweight in construction, particularly in long telephoto lenses. Also makes filter use, particularly polarizers, easier.
M/A **Manual/auto** **mode**	Manual/auto mode allows almost instant switching from autofocus to manual operation, regardless of AF mode. **Main benefit** Reduces time lag when switching between auto and manual focus modes.
RF **Rear focusing**	With rear focusing lenses, all the lens elements are divided into specific groups with only the rear lens group moving to attain focus. **Main benefit** Provides for quicker and smoother autofocus operation.

S-ED **Super-** **extra-low** **dispersion glass**	Super-extra-low dispersion glass minimizes chromatic aberration and other optical defects to an even greater extent than standard extra-low dispersion elements. **Main benefit** Increased image clarity.
SIC **Super** **integrated** **coating**	Especially effective in lenses with a high number of elements, SIC is a multilayer coating that minimizes reflection in the wider wavelength range. **Main benefit** Reduces ghost flare to a negligible level.
SWM **Silent wave** **motor**	Nikon's silent wave technology is used in to convert 'travelling waves' into rotational energy for focusing. **Main benefit** This enables accurate and quiet autofocus operation at high speed.
VR **Vibration** **reduction**	Vibration reduction lenses utilize internal sensors that detect camera shake and motors that automatically adjust the lens elements to minimize blur. **Main benefit** This technology reduces the occurrence of blur in images caused by camera shake, and allows handholding of the camera at shutter speeds slower than with a conventional lens.* * Nikon advertises that this can be up to three stops slower than a conventional lens. The rule of thumb is that you can handhold a normal lens at shutter speeds equal to its focal length, for example to hand hold a 200mm lens you must have a shutter speed of a minimum 1/200sec. Using VR technology this shutter speed could be reduced to 1/25sec. While this may be accurate in the test labs, I have used the AF VR 80–400mm f/4.5–5.6D ED lens extensively in the field and I would trust it to a maximum of two stops difference. Even then, I still prefer to support it whenever possible.

Focal length and angle of view

How the subject is reproduced in the final image depends on the focal length and angle of view of the lens used. Lenses with a short (small) focal length have a wide angle of view, while those with a long focal length have a narrow angle of view.

Picture angle

Picture angle is dictated by the angle of view of the lens, the shorter the focal length the wider the angle of view. A longer focal length will narrow the angle of view, and the subject will appear larger in the frame.

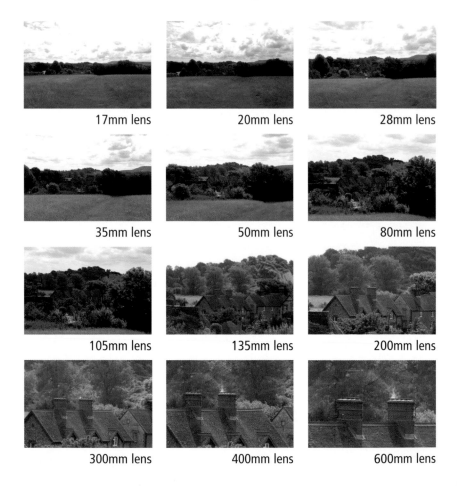

17mm lens	20mm lens	28mm lens
35mm lens	50mm lens	80mm lens
105mm lens	135mm lens	200mm lens
300mm lens	400mm lens	600mm lens

Because the size of the CCD in the D70 (and indeed in all Nikon digital cameras) is smaller than a 35mm film frame, the focal length of the lens is effectively increased by a factor of 1.5x. For example, a 200mm lens on a Nikon digital camera will give an angle of view equivalent to a 300mm lens on a 35mm film camera. Therefore, when selecting lenses it is important to remember how this effective increase in focal length will alter the perspective of your composition. The table, below, provides a quick reference guide for conversion.

Referring to this table you can see that, as an example, a 28mm wide-angle lens on a film camera would be closer to a standard lens on the D70 and to get the same wide angle of view on the D70 you would have to choose a lens with a focal length of around 18mm.

Focal length magnification factor

Focal length in 35mm (mm)	12	17	18	20	28	35	50	70	80
= Focal length with D70	18	25.5	27	30	42	52.5	75	105	120
Focal length in 35mm (mm)	105	135	180	200	300	400	500	600	800
= Focal length with D70	157.5	202.5	270	300	450	600	750	900	1200

Lens hoods

In certain areas of photography, particularly outdoor photography of subjects such as landscapes, the lens hood is indispensable. The purpose of the lens hood is to protect against light scatter in the lens barrel, which shows in the final image as flare. Telephoto lenses are particularly prone to this phenomenon.

Tip

When using a lens hood on a wideangle lens check to ensure no vignetting occurs at the corners of the image.

Perspective

Perspective is determined by the camera-to-subject distance and relates to the size and depth of subjects within the image space. Look at the series of images below and you will notice that, although the size of the cross in the foreground remains the same in each picture, its relationship to the surrounding area varies considerably, depending on the focal length used. With a wideangle lens, one with a short focal length, more of the foreground and background are included and a sense of depth is created in the image. With a telephoto lens, one with a large focal length, the background and foreground elements are compressed. Because of its sub-35mm size the D70's sensor effectively multiplies focal lengths, see page 179, which in turn compresses perspective.

Below: Changing the focal length allows you to change the camera-to-subject distance and thus the perspective of a subject in its environment without altering the principal subject's magnification.

17mm lens

50mm lens

85mm lens

135mm lens

Wideangle lenses

Wideangle lenses are ideal for isolating the subject, while relating it to its environment. By increasing spatial relationships they also help to create depth in an image, which, coupled with their large depth of field, makes them a favourite of landscape photographers.

Standard lenses

Standard lenses provide roughly the same angle of view as the human eye. Because of the D70's focal length multiplication factor a standard lens is around 35mm. Some zoom lenses that include this standard focal length in their range are now known as standard zooms.

Telephoto lenses

Telephoto lenses narrow the angle of view and flatten perspective. Short telephoto lenses, around 70–105mm with the D70, are commonly used in portraiture. While, longer telephoto lenses are typically used when it's impossible to get close to the subject, often in wildlife or sports photography. The size of these lenses means that handholding can be difficult. With heavy and long lenses a tripod or other form of support becomes essential to minimize shake.

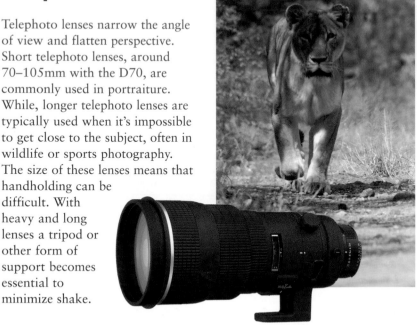

Macro lenses

For a lens to be a true macro lens it should be able to achieve a reproduction ratio of 1:1 or greater. Because conventional lenses begin to lose their powers of resolution at these degrees of magnification – due to the differing angle at which light enters the lens – macro lenses have been designed to deal specifically with the characteristics of close-up photography.

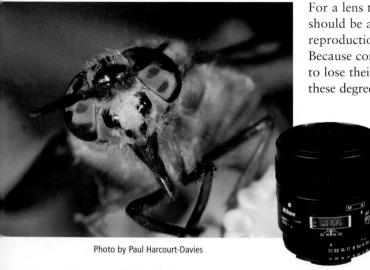

Photo by Paul Harcourt-Davies

Teleconverters

Teleconverters are a relatively inexpensive way of increasing the focal length of your lenses. Nikon teleconverters are available in three versions: TC-14E II, TC-17E II and TC-20E II. These increase focal lengths by 1.4x, 1.7x and 2x respectively.

The downside to teleconverters is a slight loss in quality of the final image and a loss in light. The three teleconverters reduce the maximum aperture by 1, 1.5 and 3 stops respectively. The minimum focusing distance of a lens is unaffected by using a teleconverter, which can be useful in macro photography.

When using a teleconverter reduces the maximum aperture to less than f/5.6, the D70's autofocus system may become unpredictable.

Tip

Teleconverters are compatible with all AF-I and most AF-S lenses. Always read the lens instruction booklet before attaching.

Fixed or zoom lenses

When buying lenses you will have a choice between fixed focal length lenses, also known as prime lenses, and zoom lenses that cover a range of focal lengths.

Zoom lenses used to be considered lower quality, but they have now largely caught up. Zooms provide an affordable option that offers the versatility of a range of focal lengths, while still maintaining a relatively high-quality image.

Nikkor lens compatibility

While one of the advantages of the D70 is the wide range of Nikkor lenses, not all lens types provide the same degree of compatibility.

Lens type	Focusing compatibility	Exposure compatibility
G-type, D-type AF AF-S, AF-I also available	All autofocus modes and rangefinder. Manual focusing centre-weighted and focus-area-linked spot metering.	All auto- and manual exposure modes. 3D colour matrix.
AF-S/AF-I Teleconverter	As above.*	As above.
PC-Micro 85mm f/2.8D	Manual, with rangefinder (except with tilt or shift).	As above.
Other AF (except F3AF lenses)	As above, except when lenses are zoomed at their minimum focus setting the rangefinder may not work.	All auto- and manual exposure modes. Colour matrix (not 3D), centre-weighted and focus-area-linked spot metering.
AI-P	Manual only, with rangefinder.* modes. Colour matrix (not 3D), centre-weighted and focus-area-linked spot metering.	All auto- and manual exposure
AI-, AI-S or Series E AI modified	As above.*	Manual exposure mode only and no metering.
Medical 120mm f/4	Manual only, with rangefinder.	Manual at shutter speeds less than 1/125sec. No metering.
Reflex	Manual only, no rangefinder. and no metering.	Manual exposure mode only
PC	Manual, with rangefinder (except with tilt or shift).	Manual exposure mode only and no metering.
IX	Incompatible.	Incompatible.

*autofocusing and the electronic rangefinder are unpredictable when used with a maximum aperture narrower than f/5.6

DX lenses

When the D70 was released there were four specially designed DX lenses available, including the AF-S DX Zoom-Nikkor 18–70mm f/3.5–4.5G IF-ED lens that is available with the D70 in kit form.

AF DX FISHEYE 10.5MM f/2.8G ED

Optical features CRC, DX, ED, G

Angle of view 180°

Minimum focus distance 0.14m

Aperture range f/2.8–f/22

Filter size Rear-attachment

Lens hood Built-in

Dimensions 63 x 62.5mm

Weight 305g

AF-S DX 12–24MM f/4G IF-ED

Optical features ASP, DX, ED, G, IF, M/A, SWM

Angle of view 99°–61°

Minimum focus distance 0.3m

Aperture range f/4–f/22

Filter size 77mm

Lens hood HB-23

Dimensions 82.5 x 90mm

Weight 485g

AF-S DX 17–55MM f/2.8G IF-ED

Optical features DX, ED, G, IF, M/A, SWM

Angle of view 79°–28°50'

Minimum focus distance 0.36m

Aperture range f/2.8–f/22

Filter size 77mm

Lens hood HB-31

Dimensions 85.5 x 110.5mm

Weight 755g

AF-S DX 18–70MM f/3.5–4.5G IF-ED

Optical features ASP, DX, ED, G, IF, M/A, SWM

Angle of view 76°–22°50'

Minimum focus distance 0.38m

Aperture range f/3.5–f/22

Filter size 67mm

Lens hood HB-32

Dimensions 73 x 75.5mm

Weight 390g

Nikkor lens chart

There are too many Nikkor lenses to mention them all here. So this list covers those that users of the D70 are most likely to purchase.	Optical Features
AF 14MM f/2.8D ED	ASP, D, ED, RF, SIC
AF 20MM f/2.8D	CRC, D, SIC
AF 24MM f/2.8D	CRC, D, SIC
AF 35MM f/2D	D, SIC
AF 50MM f/1.4D	D, SIC
AF MICRO 60MM f/2.8D	D, SIC
AF 85MM f/1.8D	D, RF, SIC
PC MICRO 85MM f/2.8D	D, CRC, SIC
AF DC 105MM f/2D	D, DC, RF, SIC
AF MICRO 105MM f/2.8D	D, CRC, SIC
AF DC 135MM f/2D	D, DC, RF, SIC
AF 180MM f/2.8D IF-ED	D, ED, IF, SIC
AF MICRO 200MM f/4D IF-ED	D, ED, IF, M/A
AF-S 300MM f/4D IF-ED	D, ED, IF, M/A, SWM
AF-S VR 24–120MM f/3.5–5.6G IF-ED	ASP, ED, G, IF, SWM, VR
AF 28–70MM f/2.8 IF-ED	ASP, D, ED, IF, M/A, SWM, SIC
AF 28–105MM f/3.5–4.5D IF	ASP, D, IF, SIC
AF 28–200MM f/3.5–5.6G IF-ED	ASP, ED, G, IF, SIC
AF 35–70MM f/2.8D	D
AF MICRO 70–180MM f/4.5–5.6D ED	D, ED
AF-S VR 70–200MM f/2.8G IF-ED	ED, G, IF, M/A, SIC, SWM, VR
AF 70–300MM f/4–5.6D ED	D, ED, SIC
AF VR 80–400MM f/4.5–5.6D ED	D, ED, SIC, VR

Angle of View	Min. Focus Distance	Minimum Aperture	Repro Ratio	Filter Size	Dimensions Dia. x Length	Weight
90°	0.2m	f/22	1:6.7	rear	87 x 86.5mm	670g
70°	0.25m	f/22	1:8.3	62mm	69 x 42.5mm	270g
61°	0.3m	f/22	1:8.9	52mm	64.5 x 46mm	270g
44°	0.25m	f/22	1:4.2	52mm	64.5 x 43.5mm	205g
31°30′	0.45m	f/16	1:6.8	52mm	64.5 x 42.5mm	230g
26°30′	0.219m	f/32	1:1	62mm	70 x 74.5mm	440g
28°50′	0.9m	f/16	1:2	62mm	71.5 x 58.5mm	380g
28°30′	0.39m	f/45	1:2	77mm	83.5 x 109.5mm	770g
15°20′	0.9m	f/16	1:7.7	72mm	79 x 111mm	640g
15°20′	0.314m	f/32	1:1	52mm	75 x 104.5mm	560g
12°	1.1m	f/16	1:7.1	72mm	79 x 120mm	815g
9°	1.5m	f/22	1:6.6	72mm	78.5 x 144mm	760g
8°	0.5m	f/32	1:1	62mm	76 x 193mm	1,190g
5°20′	1.45m	f/32	1:3.7	77mm	90 x 222.5mm	1,440g
61°–13°20′	0.5m	f/22	1:4.8	72mm	77 x 94mm	575g
53°–22°50′	0.7m	f/22	1:5.6	77mm	127 x 89mm	890g
53°–15°50′	0.22m	f/22	1:2	62mm	73 x 81.5mm	455g
53°–8°	0.44m	f/22	1:3.2	72mm	68.5 x 71mm	360g
44°–22°50′	0.28m	f/22	1:7.7	62mm	71.5 x 94.5mm	665g
22°50′–9°	0.37m	f/32	1:1.32	62mm	75 x 167mm	1,010g
22°50′–8°	1.5m	f/22	1:6.1	77mm	87 x 215mm	1,470g
22°50′–5°20′	1.5m	f/32	1:3.9	62mm	74 x 116mm	505g
20°–4°	2.3m	f/32	1:4.8	77mm	91 x 171mm	1,340g

Chapter **7**

Accessories for the D70

Anyone who has caught the photographic bug will know that once the basic skills of photography are honed the desire to push your creative boundaries becomes inevitable. The great advantage of the D70 is its ability to match you all the way.

It is impossible to cover all the available accessories in this book and some have already been covered in the flash, close-up and lens chapters. The following are some of the more commonly used accessories with some pointers on their possible use in the field.

Caps

The D70 is supplied with a BF-1A body cap. Keep this in place to protect the D70 when a lens is not attached. The kit-form D70 comes with the AF-S DX Zoom-Nikkor 18–70mm f/3.5–4.5G IF-ED lens. Protect the lens, when not in use, with the LC-67 front cap and the LF-1 back cap.

The D70 is also supplied with an eyepiece cap. Attach this when using the D70 without your eye to the viewfinder. This will prevent any stray light from entering the viewfinder and effecting the meter readings of the 1,005 pixel RGB sensor.

AN-D70 neck strap

The D70 comes supplied with the AN-D70 neck strap, which can be attached as described on page 31.

CF-D70 case

The CF-D70 ever-ready case will house a D70 with the AF-S DX Zoom-Nikkor 18–70mm f/3.5–4.5G IF-ED, or other standard-size lens attached.

BM-4 LCD cover

The D70 comes equipped with a BM-4 LCD cover. This can be attached to protect the LCD monitor (see page 31), and should be kept attached whenever possible. The BM-4 LCD cover is clear in the middle, allowing you to view images on the monitor even when the cover is attached.

EN-EL3 rechargeable Li-ion battery

The D70 comes supplied with the EN-EL3 rechargeable Li-ion battery, unlike Ni-Cd and Ni-MH batteries it does not need to be run down completely before being recharged, however it will lose its charge when not in use so charge immediately before use.

⚠ Common errors

Although the D70 is remarkably easy on battery life, allowing as many as 2,000 shots on one charge of the EN-EL3, it is still advisable to always carry a fully charged spare in the field.

MH-18 and MH-19 chargers

The MH-18 quick charger (supplied) connects to the 100–240V (AC) mains and charges the EN-EL3 Li-ion battery. The MH-19 charges two EN-EL3 batteries and can be connected to the 100–240V (AC) mains or to a 12V DC in-car cigarette lighter.

MS-D70 CR2 battery holder

The D70 can be run on CR2 batteries, although the EN-EL3 has a longer life and can be recharged. To use CR2 batteries load them into the MS-D70 CR2 battery holder, see page 31.

EH-5 AC adaptor

Powers the D70 from the mains, and is recommended to save on battery power and maximize performance, or when using mirror lock-up.

EG-D100 video cable

The EG-D100 video cable connects the D70 to either a television or VCR.

UC-E4 USB cable

The UC-E4 USB cable connects the D70 to a computer. Either to transfer image data to the computer or to control the D70 via Nikon Capture 4.1. Connect the D70 directly to the computer rather than via a USB hub.

ML-L3 wireless remote control

The ML-L3 wireless remote control for shutter release is useful particularly when using the D70 with a tripod. Triggering the shutter remotely reduces camera shake.

DR-6 right-angle viewfinder

Attaching a right-angle viewfinder to the D70 aids operation when viewing from above. It is particularly useful for macro photography.

DG-2 magnifier and eyepiece adaptor

The DG-2 magnifier enlarges the viewfinder image. It must be attached via an eyepiece adaptor.

Dioptre-adjustment lenses

The D70 has a built-in dioptre-adjustment control, see page 35. However, if the range of adjustment that it offers isn't great enough, you can use one of a range of dioptre-adjustment lenses.

Nikon Capture 4 v. 4.1 or later

The D70 is supplied with Nikon View or PictureProject software that allows you to view, edit and store digital images. Nikon Capture 4 provides additional editing functions, as well as allowing remote operation of the D70 and other Nikon cameras from a computer. See page 198 for how to connect to a computer.

Note
Although Nikon Capture 4 does cost extra, the options that it provides for post-camera processing are worth the money.

Filters

While a wide range of digital filters can be applied in post-camera image-manipulation software packages, optical filters still have their place in digital photography.

Nikon produces a range of filters that can be used with the D70 and there are also a large number available from third-party manufacturers.

UV, skylight and clear filters

These filters are useful for two purposes: eliminating UV haze in the atmosphere and clarifying the colours in pictures, and protecting your lenses. The slight pink tinge of the skylight filter adds a weak warming effect to images. Many photographers leave a UV filter attached to their lenses for protection. If you choose do this, buy the best quality filter you can afford so as not to degrade image quality.

Nikon also produce a Neutral Clear filter that can be used to protect your lens without altering the image in any way.

Polarizing filters

Polarizing filters cut out polarized light. The effect of this is twofold: colours appear more saturated, particularly blue skies, and reflected glare from anything other than metal surfaces is reduced.

Circular, rather than linear polarizers are necessary to maintain the reliability of the D70's autofocus system. A circular polarizer is attached to the front of the lens and rotated to vary the amount of polarization.

Colour correction filters

Nikon, and other manufacturers, produce a number of filters that are designed to correct colour casts caused by using daylight-balanced film under varying colour temperatures. Because the D70 allows you to set and even fine-tune the colour balance colour correction filters are now redundant. Adding additional elements in front of the main lens will cause image quality to deteriorate, for this reason it is much better adjust colour balances in-camera, see page 57, rather than by using filters.

Netural density filters

Neutral density filters can still be useful for the D70. These filters, as the name suggests, add no colour to an image, they simply reduce the amount of light reaching the CCD. They are often used to increase exposure times when capturing motion on film, for instance making waterfalls blur.

The reason that you may want to use neutral density filters with the D70, is that the ISO-E range only extends down to ISO-E 200. Using a neutral density filter cuts down the amount of light entering the lens and

allows you to use longer shutter speeds to blur motion. Remember to engage long exposure noise reduction for exposures over one second in order to get the smoothest images with the least noise.

Graduated filters

Nikon don't manufacture graduated filters. However, slot-in type systems from a range of manufacturers can be used. But this is an area that has been much improved by digital techniques and there is often no real need to apply graduated filters manually when they can be applied later in an imaging application.

⚠ Common errors

Strongly coloured filters can affect the 1,005 pixel RGB metering sensor. For this reason you should switch to centre-weighted metering when you are using them.

Filters for black & white

Black & white photographers often use strongly coloured filters to increase contrast when rendered in black & white. The D70 records colour images so the best way to obtain black & white is to use NEF files and import them to an imaging program. As you are doing this it makes sense to apply contrast adjustments then rather than use optical filters.

Notes

Lenses with internal focusing (see page 176) enable easier and more accurate use of circular polarizers.

Because neutral density filters are colour neutral, they will not affect the D70's 3D colour matrix metering system, unless they are gradauated.

Filters can be easily damaged during transport or storage. Use a third-party manufactured filter holder, or Nikon's own CA-1, which can hold up to six 52mm or 62mm thread filters, to protect them.

Shooting for digital filters

Increasingly photographers are choosing not to use optical filters. Similar results can be obtained in image manipulation programs by either applying digital filters or by tweaking image attributes such as saturation and hue. If you are going to apply digital filters then don't apply any in-camera image optimization. Shoot in the NEF RAW mode and the Adobe RGB colour space as this will give you the most flexibility.

Storage devices

The D70 stores image data on a slot-in storage device, either a CompactFlash card (type I or type II) or a Microdrive. The number of images that can be stored will depend on the size of the device and the size of the image files. The write speed of the storage device is also a determining factor in how quickly data is written from the temporary buffer memory in the camera and will affect the speed at which successive pictures can be taken in continuous shooting mode.

Tips

CompactFlash cards provide a number of advantages over Microdrives. Because Microdrives have moving parts I have found them less reliable in conditions such as low temperatures. The moving parts also generate heat and sometimes this can affect heat-sensitive components such as the sensor.

Microdrives will write faster when they are already in use and the internal disk is spinning.

Type I or II cards

CompactFlash cards are available in type I or type II formats. Type II cards are slightly thicker, however neither card type offers inherent performance advantages over the other. Simply choose the card to suit your needs and budget.

EC-AD1 card adaptor
Using the EC-AD1 card adaptor allows type I CompactFlash cards to be inserted into PCMCIA slots.

Coolwalker MSV-01
If you don't have immediate access to a computer, you can download your images onto a portable device such as the Coolwalker.

The Coolwalker allows you to download, organize and view 30 GB of images. Moreover, the Coolwalker is fully compatible with the NEF format.

The following memory cards are approved by Nikon for use in the D70.
Other cards, while not necessarily approved, may work perfectly well and I
have successfully tested a number of different memory cards with the D70.

Brand	Card series	Capacity
Sandisk	SDCFB	16 MB, 48 MB, 80 MB, 96 MB, 128 MB, 160 MB, 256 MB, 512 MB, 1 GB
	SDCFB (Type II)	192 MB, 300 MB
	SDCF2B (Type II)	256 MB
	SDCFH (Ultra)	128 MB, 192 MB, 256 MB, 384 MB, 512 MB, 1 GB
	SDCFX	512 MB, 1 GB
Lexar Media	4x USB	16 MB, 32 MB, 64 MB
	8x USB	16 MB, 32 MB, 48 MB, 64 MB, 80 MB
	10x USB	160 MB
	12x USB	64 MB, 128 MB, 192 MB, 256 MB, 512 MB
	16x USB	192 MB, 256 MB, 320 MB, 512 MB, 640 MB, 1 GB
	24x USB 24x (Write Acceleration Technology) USB	256 MB, 512 MB
	32x (Write Acc. Tech.) USB	1 GB
	40x (Write Acc. Tech.) USB	256 MB, 512 MB, 2 GB, 4 GB
Hitachi	Compact FLASH HB28 C8x	16 MB, 32 MB
Microdrive	DSCM	512 MB, 1 GB
3K4		2 GB, 4 GB

*At the time of writing a new firmware update had recently made the D70 compatible with
CompactFlash cards of over 4GB capacity, though no specific details were available

Chapter **8**

Connecting the D70 to an **external device**

The D70 can be connected to a
computer for viewing, editing and
storing images, as well as to a
television or VCR. For printing,
images can be downloaded to a
computer or sent direct to a suitable
printer (JPEGs only).

Connecting to a computer

The D70 can be connected to either
a Mac or PC via the UC-E4 USB
cable. Using the Nikon View or
PictureProject software supplied
images can be downloaded from
the Nikon D70 to the computer
where they can be viewed, edited
and stored.

The computer must have a USB
port and should be running either
Windows XP (Home or
Professional editions), 2000
Professional, Millennium edition
(Me) or 98 Second edition (Se)
operating systems on a PC; or Mac
OS X or Mac OS 9 operating
systems on an Apple Mac. It also
needs a CD-Rom drive in order to
install the software.

The D70 is compatible with
PictureProject 1.0 or later, Nikon
View 6.2.1 or later and Nikon
Capture 4.1 or later. Note that

PictureProject 1.0 is compatible
with Mac OS X 10.1.5 or later. If
you use Mac OS 9 or earlier then
you will have to use Nikon View
6.2.1 or later.

Tip
Bear in mind that editing and
storing images on a PC can quickly
utilize your available memory and
hard drive capacity. From experience,
I would recommend a minimum of
256 MB or, better still, 512 MB of
RAM memory and a minimum of a
20 GB hard disk drive.

⚠ Common errors

If you receive an 'Insufficient free space on startup disk' message this can be because there is not enough memory available on your computer's hard drive. Nikon View requires that the amount of free space on the hard drive that your operating system is on is at least double the size of the memory card being used.

Before connecting the camera to a computer, make sure you have installed the supplied software, following the instructions in the software manual carefully. You will need to set the USB option in the SET UP menu according to the operating system used by your computer (see page 46). Use the table below to select the USB setting.

Operating system	USB setting
Windows XP Home edition Windows XP Professional Mac OS X	Select **PTP** or **MASS STORAGE** from the menu options
Windows 2000 Professional Windows Millennium edition (Me) Windows 98 Second edition (Se) Mac OS 9	Select **MASS STORAGE** from the menu options

Note
With the optional Nikon Capture 4 v. 4.1 or later software the D70 can be operated remotely via a computer. For remote operation the USB setting must be set to PTP.

Tip
Before beginning image transfer to an external device, make sure that the battery is fully charged so that data transfer is uninterrupted. Alternatively connect the camera to a mains outlet using the optional EH-5 AC adaptor.

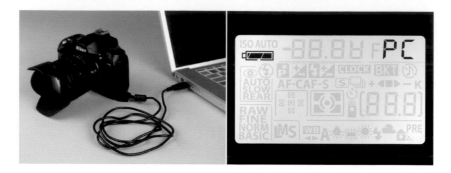

1) To connect the D70 to a suitable computer, first turn on your computer and wait for it to complete the start-up process. Make sure the D70 is turned OFF and fit the (supplied) US-E4 USB cable into the USB connector (**16**) on the side of the camera. (The smaller of the two connectors fits into the D70.) Fit the other end of the US-E4 USB cable to a free USB port on your computer.

Tip
With the growing number of USB devices available it is popular now to use a USB hub with your computer. However, avoid connecting the D70 to the computer via one of these hubs and only connect the camera directly to the computer. Otherwise the connection may prove unreliable.

2) Turn on the D70. The camera displays will change depending on the USB setting in use. If **MASS STORAGE** is selected then **PC** will be displayed in the control panel and viewfinder. If **PTP** is selected, the camera displays will only change if the D70 is being operated remotely using the optional Nikon Capture 4 Camera Control software.

⚠ Common errors

If PTP was selected using Windows 2000 Professional, Windows Millennium edition (Me) or Windows 98 Second edition (Se), the Windows hardware wizard will be displayed on the computer when you turn on the D70. Click CANCEL on the dialogue box and then disconnect the D70.

If PTP was selected using Mac OS 9 then a dialogue box will be displayed stating that the computer is unable to use the driver needed for the Nikon DSC_D70 USB device. Click CANCEL on the dialogue box to close it and then disconnect the camera.

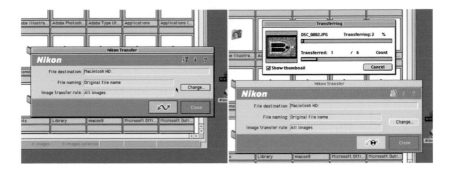

1) When you turn on the D70 and Nikon View or PictureProject is installed on your computer, Nikon View or PictureProject will launch automatically and the dialogue box above will be displayed on the computer's monitor.

2) Select a destination folder on your computer's hard disk drive to transfer the pictures into using the file destination and naming window. Then, click on the ⚞ box to begin image transfer.

Notes

Strictly speaking a RAW file is not a file type, whereas a NEF file is. Check that your imaging software supports NEF files. The latest plug-in for Adobe Photoshop CS now supports the D70's NEF files. To download this plug-in visit www.adobe.com

Never turn OFF or disconnect the camera while transfer is in progress.

Once image transfer is completed a dialogue will be displayed on the computer's monitor and you can disconnect the D70.

⚠ Common errors

If you get an 'Unsupported File Format' message when trying to view NEF files in Nikon View or another imaging program it may be because they were incorrectly transferred. Some applications, such as Image Capture in Mac OS X, can corrupt NEF files when transferring them. To ensure that this doesn't happen, transfer files through Nikon View, PictureProject, or by 'dragging and dropping' the files from the memory card.

To disconnect the D70 from the computer (B)

If PTP is selected in the USB menu option then the camera can be safely switched OFF and the US-E4 USB cable removed as soon as image transfer is completed.

If **MASS STORAGE** is selected in the USB menu option then the D70 must first be removed from the computer system, as described below:

Windows XP Home edition and Windows XP Professional edition
In the taskbar, click the **SAFELY REMOVE HARDWARE** icon and then select **SAFELY REMOVE USB MASS STORAGE DEVICE** from the subsequent menu option shown on the computer monitor.

Windows 2000 Professional
In the taskbar, click the **UNPLUG OR EJECT HARDWARE** icon and then select **STOP USB MASS STORAGE DEVICE** from the subsequent menu.

Windows Millennium edition (Me)
In the taskbar, click the **UNPLUG OR EJECT HARDWARE** icon and then select **STOP USB DISC** from the subsequent menu option shown on the computer monitor.

Windows 98 Second edition (Se)
In **MY COMPUTER**, right click the mouse on the removable disc corresponding to the D70 and select **EJECT** from the drop-down menu.

Mac OS X and Mac OS 9
Using the mouse drag the **NIKON D70** icon into the **TRASH**.

Viewing shooting data (A)

It is often very useful to look at the technical details of an image. However, the exact way to view this data on screen depends on whether you are using Nikon View, PictureProject, Nikon Capture or any other imaging application. Refer to the software manual for full details.

Connecting the D70 to a television or VCR (A)

Images taken on the D70 can be
played back on a television or
recorded to a VCR using the supplied
EG-D100 video cable. To connect the
camera to either of these devices:

1) Make sure the D70 is turned OFF.
Connect the EG-D100 cable to the
VIDEO OUT socket (**14**) on the camera
and to the VIDEO IN socket on the
television, as shown (the thinner of the
two connectors attaches to the D70).

2) Turn ON the television (and VCR, if
applicable) and tune the television to
the video channel.

3) Turn the camera ON. The selected
image in the camera will be displayed
on the television screen or recorded to
videotape.

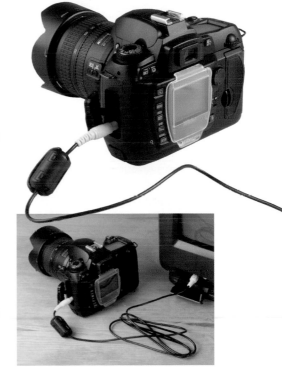

Tip
If you are planning to view or
record a number of images via the
television or VCR respectively, then
I would advise using the optional
EH-5 AC adaptor to ensure power
is retained for normal operation.
When the EH-5 AC adaptor is in
use the D70's monitor-off mode
will be set at ten minutes and
exposure meters will remain on
until manually turned off.

Notes

The monitor display on the D70 will
remain blank but the camera will
operate normally in all other aspects.

The video standard must match the
standard used by the video device.
Expect to see a drop in image
quality when pictures are displayed
on a PAL device.

Direct printing from the D70

The D70 is compatible with the PictBridge industry standard. This means that images can be printed directly from the D70 to an attached compatible printer, without having to transfer them via a computer.

System requirements

To print directly from the D70 images must be taken in one of the JPEG image quality modes (RAW files cannot be printed directly to a printer). The printer must also have a USB connection and be PictBridge compatible.

About PictBridge

The PictBridge standard provides a direct connect solution for image input and output devices by standardizing the application services for these devices. It was devised to enable the simple connection between compatible input devices (such as digital cameras) with any other compatible output devices (such as printers), irrespective of manufacturer. In so doing, it removes the technical barrier often associated with computer connectivity.

Connecting to a PictBridge printer (A)

1) On the D70, set the USB menu option to **PTP** (see page 46). (Images cannot be printed when the USB menu option is set to **MASS STORAGE**, the default setting.)

2) Make sure the printer is turned ON. The D70 should be turned OFF. Connect the supplied UC-E4 USB cable first to the USB socket on the D70, (the small connector attaches to the camera). Connect the other end of the cable directly to the printer.

3) Turn the camera ON and a **WELCOME** message will be displayed on the D70's monitor, followed by a PictBridge menu, shown opposite.

4) Use the multi selector on the D70 to select the required menu option and press ENTER.

PICTBRIDGE MENU

Option	Description
Print	Allows printing of selected images either one per page or as a contact sheet on a single page (index print).
Print (DPOF)	Prints the images in their current order (see page 207). The order can be changed prior to printing but not during printing.
Setup	Allows you to elect whether 'date recorded' data is imprinted on the print and whether the image is printed with or without borders.

Tips

When taking pictures for direct printing only it is wise to maximize image quality in-camera. To simply achieve this, select **DIRECT PRINT** from the **OPTIMIZE IMAGE** menu (see page 64) or set the colour mode to either Ia (sRGB) or IIIa (sRGB), see page 68.

Alternatively, you can use the custom settings in the SHOOTING MENU to make your own manual enhancements to image quality.

Notes

The size of print and paper type and source are selected via the printer, not the camera. Refer to your printer's manual for information on setting up the printer for your requirements.

Images that are hidden using the HIDE IMAGE menu option (see page 103) are unavailable for selection for printing via the PRINT or PRINT (DPOF) options.

If an error occurs during the direct print process UNKNOWN ERROR will be displayed on the camera's monitor. Check all connections and refer to the printer's manual to resolve the problem. Using the multi selector, select CONTINUE to continue printing or CANCEL to exit the process.

Direct printing selected images (A)

1) To print selected images directly from the D70 to a printer, select **PRINT** in the PictBridge menu using the multi selector and press **ENTER**.

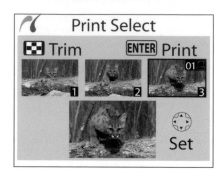

2) Use the multi selector to highlight **CHOOSE FOLDER** and press **ENTER**. All current folders will be displayed on the D70's monitor.

3) Using the multi selector, select the folder that contains the images you want to print or choose **ALL** to display all the images stored on the memory card and press **ENTER**. The menu will revert to the PRINT menu.

4) To print the photographs individually, select **PRINT** and press **ENTER**. Use the ◄ and ► arrows of the multi selector to scroll through the images (the current image is displayed at the bottom of the D70's monitor) and press the ▲ arrow to select an image and set the number of prints to

one. The selected image will be marked with a 🖼 icon. To increase or reduce the number of prints to be made use the ▲ and ▼ arrows on the multi selector after an image has been selected. To deselect an image, press the ▼ arrow on the multi selector when the number of prints is set to 1.

5) Repeat the above process until all the desired images are selected for printing. To begin printing, press the **ENTER** button on the camera.

6) To exit the PictBridge menu without printing, press the **MENU** button. To cancel the operation during printing, press **ENTER**.

7) To print a contact sheet of all the displayed images, select **INDEX PRINT** and press **ENTER**. Press **ENTER** again to begin printing.

Notes

You can make up to 99 prints of a single image at any one time.

Make sure your printer has enough paper in the paper tray for the number of pictures being printed.

Direct printing the current print order **A**

You can print the images in the CURRENT PRINT ORDER by selecting **PRINT (DPOF)** from the PictBridge menu using the multi selector.

When selected, images in the current folder will be displayed on the D70's monitor and all pictures in the CURRENT PRINT ORDER are marked with a 🖼 icon. The number of prints to be made of each image is displayed next to the 🖼 icon.

You can change the CURRENT PRINT ORDER before printing (see page opposite) or exit without printing by pressing the **MENU** button.

To begin printing the CURRENT PRINT ORDER, press **ENTER**. To cancel the operation during printing, press **ENTER**.

Selecting borders and imprinting data **A**

You can choose whether or not images are printed with a border and whether to print the date of recording on all images via the SETUP menu option in the PictBridge menu.

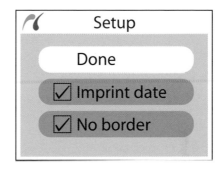

Selecting a border
By default images printed directly from the D70 are printed with a white border. If your printer supports borderless printing (refer to your printer manual for details), then you can choose to print all images without this white border.

1) Select **SETUP** in the PictBridge menu and use the multi selector to highlight **NO BORDER**. Press **ENTER** to select this option (a check mark will appear in the small box next to the menu option).

Imprint data
1) To have the date of recording imprinted on all images in the **PRINT ORDER**, select **SETUP** in the PictBridge menu and use the multi selector to highlight **IMPRINT DATE**. Press **ENTER** to select this option (a check mark will appear in the small box next to the menu option).

Cropping images for printing (A)

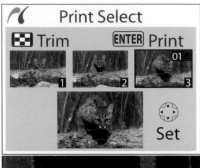

If your printer supports cropping, you can use the ▦ button to crop the images in-camera. The printer will only print the selected area.

1) To crop an image in-camera, select an image in the **PRINT SELECT** dialogue screen.

2) Press the ▦ button and rotate the main command dial to zoom in or out of the picture. To scroll to other areas of the image, use the multi selector. Once you have framed the preferred composition in the camera's monitor, press **ENTER**. The monitor will revert to the **PRINT SELECT** dialogue screen and only the selected area of the picture will be printed.

Tip
You may find that image quality is degraded when pictures are greatly enlarged. To minimize the loss of image quality, avoid making heavy crops in-camera.

GREY WOLF
Cropping your images before printing
can help to provide more dynamic
compositions. Here the right-hand side
has been cropped to position the wolf
as if it is walking into the frame

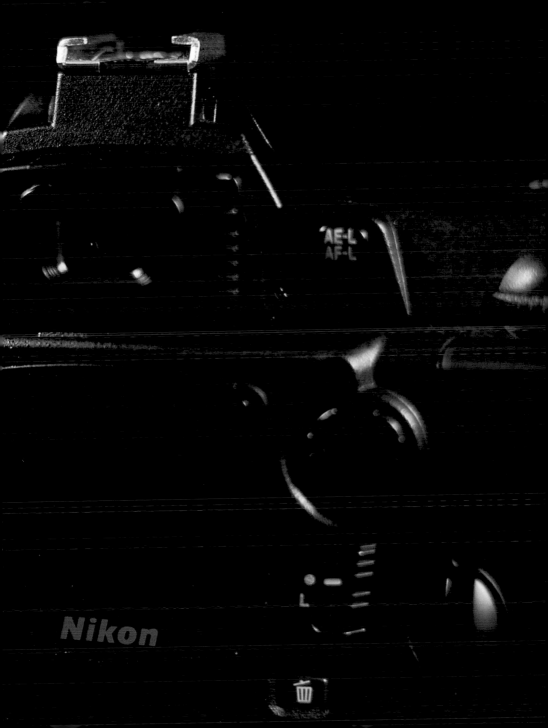

Caring for your D70

The D70 is aimed at the consumer market and, although the camera is professional in appearance, it has not been designed to withstand the moisture, dust or hard knocks that you'd expect a professional model such as the D2H to take in its stride.

It is important that you protect the D70 from inclement weather and from excessive wear and tear if you want it to last you many years. Some simple precautions will help ensure its life expectancy.

Notes

When changing lenses face the camera towards the ground. This should help to prevent dust from entering the camera body and settling on the low-pass filter.

An alternative to having the low-pass filter cleaned is using the Dust Off function in Nikon Capture 4 v. 4.1 or later. See page 47 for details.

Extreme environments

The D70 is not a professional-build camera and has not been designed to undertake vigorous workouts in excessively camera-hostile environments. However, in a world of adventure holidays and prolonged travel to further and more exotic destinations, it is likely that your D70 may accompany you to some extreme locations. If treated well there is no reason why the D70 will not survive trips to even the most inhospitable climates so long as you take certain steps to protect it.

Jungles and high-humidity environments
When using the D70 in high-humidity environments it is going to get wet and a great deal of care should be taken to protect both the outer body and the internal electronics. Your best bet is to operate the camera using a protective waterproof cover, which can be acquired from specialist retailers. If the camera does end up getting wet, to dry the camera and lenses, place them in an airtight

Basic care

Firstly, there are some basic rules that will help ensure your D70 does not malfunction. The shutter curtain and all electrical contacts are particularly vulnerable and you should avoid touching them at all times.

Dust should be removed regularly from the reflex-mirror, focusing screen and lens surface, using a blower brush instead of a cloth or, worse still (honest, I've seen it done) your finger.

Photosensors are particularly vulnerable to dust, which is drawn in by the electromagnetic properties of the CCD. The D70's CCD is covered by a low-pass filter, which should be cleaned only by a Nikon approved technician. If you choose to clean the low-pass filter yourself then first remove the lens – see page 33. Secondly, select the mirror lock-up function from the setup menu – see page 44. Depress the shutter-release button and check the low-pass filter to see if it requires cleaning. Use a blower (not a blower brush) to remove any particles of dirt. Take care never to touch the low-pass filter.

Keep the camera in a cool, dry environment, shading it from excessive heat and prolonged periods of direct sunlight.

The rear LCD monitor is delicate and you should avoid putting any pressure on it. Keep the monitor cover attached whenever you are not using the monitor to check image details, and especially when transporting or storing the D70, see page 31. If you need to clean the monitor do so using a clean dry cloth. If this doesn't work then some LCD cleaners are available: follow the manufacturer's instructions carefully and refer to a Nikon approved technician if in doubt.

I once read a letter from a disgruntled F90X owner to a photo magazine complaining that his camera no longer worked properly after he had fished it out of the river he'd dropped it in. Well, your D70 won't work in those circumstances either being, much like the F90X, an electrical product. The odd drop of rain it can cope with. The odd drop in the sea it takes personally.

container with plenty of silica gel. The gel will soak up the moisture. When the gel becomes soaked, dry it out in a pan over a fire.

African savannah and dusty environments

Africa is a dream destination for many wildlife and travel photographers. It is also one of the dustiest environments I've had the privilege of photographing. To help keep dust out of the camera I carry a leather bag, in which I place the camera when changing lenses. At the end of each day's shoot I clean the camera, lenses and filters thoroughly with a blower brush for delicate parts and an aerosol spray for the outer body. The dust will also affect the CCD and you should take care when changing lenses.

Tropical rainforests and high-rainfall environments

Rainforests are so called for a very good reason and all the electronics in the D70 react badly to a good soaking. In areas of high rainfall I use a fitted plastic cover over the camera and lens barrel to shield them from the wet. I'll change lenses in a dry-bag that I carry with me.

High-arctic and extreme-cold environments

Shooting in extreme-cold conditions is less of an issue for the camera than it is for you, the photographer. In such conditions the camera will slow down in operational speed, batteries will die quickly and the LCD panels may blank out. To ensure the camera can still operate it is wise to keep a spare battery within the confines of your clothes and close to your body for added heat, which you can then switch over.

When all else fails

If your D70 does go wrong then take it to an authorized Nikon dealer. Never try and repair it yourself as you may cause more problems than you solve.

Tip
When using an aerosol spray hold the nozzle at least 12in (30cm) away from the camera and lens surface and constantly move the nozzle so the stream of air is not concentrated in a single spot. Keep the canister vertical.

Note
The D70 may sometimes turn itself off for no apparent reason. This is caused by static electricity or poorly loaded batteries and can be rectified by turning the camera off and on again, or by removing and reinstalling the battery.

Glossary of terms

Aberration An imperfection in the image that is caused by the optics of a lens. All lenses suffer from aberrations; however, many try to correct them in a number of ways.

Angle of view The area of a scene that a lens takes in. A wideangle lens has a wide angle of view, while a telephoto lens has a narrow angle of view.

Aperture The opening in a camera lens through which light passes to expose the CCD. The relative size of the aperture is denoted by f-stops.

Artefact Incorrectly interpreted data that results in visible flaws in the image.

Buffer The in-camera memory of a digital camera. The D70 has a dynamic buffer that can write files to the memory card during shooting.

Burst size The maximum number of frames that a digital camera can shoot before its buffer becomes full.

CCD (charge-coupled device) A microchip made up of a grid of light-sensitive cells.

Chromatic aberration The inability of a lens to bring the colours of the spectrum into focus at one point. This results in fringing and can be corrected by use of aspherical lens elements.

Colour mode One of a number of colour gamut standards that an image is recorded in.

Colour temperature Description of the colour of a light source expressed in Kelvins (K). Note that 'cool' colours such as blue have high colour temperatures and vice versa.

CompactFlash A commonly used, solid state, memory card standard.

Compression The process by which digital files are reduced in size.

Contrast The range between the highlight and shadow areas of an image. Also the difference in illumination between adjacent areas.

Depth of field The amount of an image that is acceptably sharp. This is controlled by the aperture: the smaller the aperture, the greater the depth of field. Depth of field extends one third in front of and two thirds behind the point of focus.

Dioptre Unit expressing the power of a lens. Expressed as positive (enlarging) or negative (reducing) when referring to eyesight correction lenses used in viewfinder eyepieces, or close-up attachment lenses.

dpi (dots per inch) A measure of the resolution of a printer.

Exposure The amount of light that is allowed to hit the CCD, controlled by aperture, shutter speed and ISO-E. Alternatively the act of taking a photograph, as in 'making an exposure'.

Fill flash Flash combined with daylight in an exposure. Used with naturally backlit or harshly sidelit or toplit subjects to prevent silhouettes forming, or to add extra light to the shadow areas of a well-lit scene.

Filter A piece of coloured glass, or other transparent material, used to affect the colour or density of the entire scene or certain areas within a scene.

Focal length The distance, usually in millimetres, from the optical centre point of a lens element to its focal point.

Focal length multiplication factor The D70's sensor is smaller than a 35mm film frame. This means that any lens used with the D70 will provide the 35mm-equivalent focal length of 1.5x its given focal length.

fps (frames per second) The ability of a digital camera to process one image and be ready to shoot the next.

Histogram A graph used to represent the distribution of tones in an image.

Hotshoe An accessory shoe with electrical contacts that allows synchronization between the camera and a flashgun.

Hotspot A light area with a loss of detail in the highlights. This is a common problem in flash photography.

Interpolation The mathematical estimation of data, which is used to collate separate data from red, green and blue light on separate pixels and form an image with full colour information at every pixel location.

ISO-E The sensitivity of the CCD measured in terms equivalent to a film's ISO rating.

JPEG A compressed image file standard developed by the Joint Photographic Experts Group.

Megapixel One million pixels equals one megapixel. The D70 has a 6.1 effective megapixel CCD.

Memory card Removable storage device for digital cameras.

Microdrive A memory card that fits into a CompactFlash slot, but unlike CompactFlash, contains moving parts.

Mired An alternative scale of measurement of colour temperature calculated by dividing the colour temperature in Kelvins by one million.

NEF (Nikon electronic format) Nikon's own RAW file format.

Noise Coloured image interference caused by stray electrical signals.

PictBridge The industry standard for sending information for printing directly from a camera to a printer, without having to connect to a computer.

Pixels Abbreviation of 'picture elements'. The individual units that make up an image in digital form.

ppi (pixels per inch) A measure of the resolution of a digital image.

Red-eye When photographing people or animals using flash close to the optical axis, the light from the flash can bounce off the blood vessels in the retina of the eye causing the pupil to look red.

Reproduction ratio The ratio of the size of the real-life subject to its image in the focal plane.

Resolution The number of pixels that an image is comprised of. Normally given in ppi.

RGB (red, green and blue) The three colours from which the D70's CCD derives all colour information.

Rule of thirds A compositional device that places the key elements of a picture at points along imagined lines that divide the frame into thirds.

Shading The effect of light striking a photosensor, in the D70's case the CCD, at anything other than right angles is to lose resolution. This occurs most frequently at the edges of images.

Shutter speed The length of time that the shutter is open. Measured in seconds or fractions of a second.

SLR (single lens reflex) A type of camera (of which the D70 is one) that allows you to see through the camera's lens as you look in the viewfinder.

Speedlight Nikon's range of dedicated flashguns are called Speedlights.

Teleconverter A lens that is inserted between the camera body and main lens increasing its focal length.

Telephoto lens A lens with a large focal length, with a narrow angle of view making the small or distant subjects appear larger in the picture space.

Through-the-lens (TTL) metering A meter built into the camera that determines exposure for the scene by reading light that passes through the lens during picture taking.

TIFF (tagged image file format) An uncompressed digital image file.

USB (universal serial bus) A data transfer standard, used by the D70 when connecting to a computer.

White balance A function that allows the correct colour balance to be recorded for any given lighting situation.

Wideangle lens A lens with a short focal length giving a wide angle of view.

Useful web-sites

NIKON:

Grays of Westminster
Award-winning Nikon-only dealer
www.graysofwestminster.co.uk

Nikon Electronic Imaging Products
European user support
www.europe-nikon.com/support

Nikon Historical Society
The history of Nikon and Nikon products
www.nikonhs.org

Nikon Imaging Corporation
Official worlwide imaging site
http://nikonimaging.com/global

Nikon Info
Nikon user forum and gallery
www.nikoninfo.com

Nikon Links
Links to a variety of Nikon-related sites
www.nikonlinks.com

Nikon Owners' Club International
Worldwide club for Nikon users
www.nikonownersclub.com

Nikon UK
Home page for Nikon UK
www.nikon.co.uk

Nikon USA
Home page for Nikon USA
www.nikonusa.com

Nikon Worldwide Network
Worldwide headquarters home page
for Nikon Corporation
www.nikon.com

GENERAL PHOTOGRAPHY:

Digital Photography Review
Digital camera reviews, buyers' guides,
users' forums and digital image
comparisons
www.dpreview.com

Natural Photographic
Wildlife photography and journalism by
Chris Weston
www.naturalphotographic.com

Rob Galbraith
Digital photography news, reviews,
tutorials and discussion forums for
professional photographers
www.robgalbraith.com

PHOTOGRAPHY PUBLICATIONS:

Photographers' Institute Press
Books and magazines on a range of
photography-related subjects
www.gmcbooks.com

Index

About the author

Chris Weston is a full-time wildlife photographer and photojournalist. He photographs elusive animals in some of the most camera-hostile regions of the world and switched to the digital format in 2003, working with the Nikon system because of its reputation for high quality and dependability.

A regular contributor to many magazines and the author of eight books, to date, Chris also runs numerous photographic workshops both in the UK and overseas. He is a member of the Nikon Owners' Club International, the Honorary Secretary of the Photographers' Institute and an affiliate member of Canopy, a US-based non-profit organization active in the conservation of endangered species and habitats.

Acknowledgments

While it is the author's name that appears on the cover of the book and, therefore, it is he who takes the plaudits (or otherwise!), no book would be possible without the combined efforts of the supporting team. I would like to thank everyone at the Photographers' Institute Press who helped in the production of this book, including Paul Richardson, Gerrie Purcell, James Beattie, Gilda Pacitti and Anthony Bailey. Also, to Gray Levett at Grays of Westminster in London and to Chris Varley who came up trumps when others went missing. My continued gratitude to Paul Harcourt Davies, not just for his expertise in all things small, but also for his friendship. And finally, to my family: Claire, my wife, who puts up with my deadline-induced tantrums and still makes the coffee, and to Josh, for keeping the nights quiet and the days full of laughter.